VALE OF YORK

THROUGH TIME

Paul Chrystal &
Simon Crossley

AMBERLEY PUBLISHING

Acknowledgements

Thanks to Melvyn Browne for permission to use a number of his pictures in the West of York chapter. All of the modern photography is by Paul Chrystal.

Paul Chrystal and Mark Sunderland are authors of the following titles in the *Through Time* series published in 2010: *Knaresborough*; *North York Moors*; *Tadcaster*; *Villages Around York*; *Richmond & Swaledale*; *Northallerton*.

Paul Chrystal and Simon Crossley are authors of the following titles in the series published or to be published in 2011: *Hartlepool*; *In & Around York*; *Harrogate*; *York Places of Education*; *Redcar, Marske & Saltburn*; *York Trade & Industry*; *Pocklington & Surrounding Villages*; *Barnard Castle & Teesdale*.

Other books by Paul Chrystal: *A Children's History of Harrogate & Knaresborough*, 2011; *A to Z of Knaresborough History Revised Edn*, 2011; *Chocolate: The British Chocolate Industry*, 2011; *York and Its Confectionery Industry*, 2011; *Confectionery in Yorkshire – An Illustrated History*, 2011; *Cadbury & Fry – An Illustrated History*, 2011; *The Rowntree Family and York*, 2012; *A to Z of York History*, 2012; *The Lifeboats of the North East*, 2012.

To see more of Simon Crossley's work please go to www.iconsoncanvas.com; to see Mark Sunderland's work visit www.marksunderland.com

'The Vale of York is the most beautiful and romantic vale in the world,
the Vale of Normandy excepted.'
– Chevalier Bunsen

First published 2011

Amberley Publishing
The Hill, Stroud
Gloucestershire, GL5 4EP

www.amberley-books.com

Copyright © Paul Chrystal & Simon Crossley, 2011

The right of Paul Chrystal & Simon Crossley to be identified as the Author of this work has been asserted in accordance with the Copyrights, Designs and Patents Act 1988.

ISBN 978 1 4456 0613 2

British Library Cataloguing in Publication Data. A catalogue record for this book is available from the British Library.

Typeset in 9.5pt on 12pt Celeste.
Typesetting by Amberley Publishing.
Printed in the UK.

Introduction

Chevalier Bunsen got it absolutely right, even if he did rather spoil it at the end: the Vale of York remains today one of Britain's most beautiful – and romantic – regions; 'an area of outstanding natural beauty' in today's parlance.

This book clearly demonstrates that beauty, showing as it does towns and villages in the Vale from Thirsk in the north to Wetherby in the south from the earliest days of the last century. These old images are juxtaposed with modern photographs showing just how much things have changed over the intervening decades, or indeed how they have remained largely the same.

We start our journey in Thirsk – one of the four market towns covered in the book – properly in the Vale of Mowbray, which makes up the northern part of the Vale of York. Here, in what has become known as 'James Herriot country', we find bullrings and bull-baiting, the famous clock and the place where Henry Percy met his cruel death at the hands of an angry mob. Moving east to the edge of the Vale we arrive at Sutton to find the unique crab wheel and ascend the North York Moors escarpment by way of the exhilarating Sutton Bank with its hairpin bend and unforgiving incline.

Moving south, we arrive at Ripon, Britain's oldest city, with its beautiful cathedral and its Bellman and Wakeman – ancient offices which persist today and are two of our oldest surviving ceremonies. Less grand, but just as important to Ripon for all that, are two other characters: bootman Tom Crudd and 'witch' Nanny Appleby. North-west of this finely preserved latter-day spa is West Tanfield, which affords us 'one of the most charming [views] in England'.

Boroughbridge is next with its disastrous battle and then Isurium and the fine mosaics excavated from the Roman town, most of which still lies under here. Myton, scene of another disastrous battle – the White Battle – and then on to Easingwold with its elegant Georgian architecture and its picturesque green. Nearby Raskelf is special due its wooden church tower (only one of two left in the country) and its well restored pinfold. We visit a number of other villages, notably Tollerton and its bandits, Tholthorpe and Linton, both homes to the Royal Canadian Airforce during the Second World War, Kirk Hammerton with its Saxon church, neighbouring Green Hammerton visited by Dick Turpin *en route* to scullduggery in York, and Nun Monkton with its astonishing working green.

And so on to Wetherby where many before us have stopped on their way to and from London and equidistant Edinburgh. Like them we pause at the many hostelries here and admire the all-important bridge – latest in a line of bridges that have defined the town forever. Then there is the Market Place and the Shambles – sold off with the rest of the town by the 6th Duke of Devonshire to finance his pile in Derbyshire.

A picture of the old and new then in this fascinating region – highly scenic and brimming with history. It is, of course, not comprehensive: other towns and villages in the Vale are dealt with in my earlier books covering York itself and surrounding villages, Tadcaster, Harrogate, Knaresborough and Northallerton. Nevertheless, there is more than enough here to give a flavour of the nature and characteristics of the Vale of York of yesteryear and today: 'the most beautiful and romantic vale in the world...'

Paul Chrystal, York, October 2011

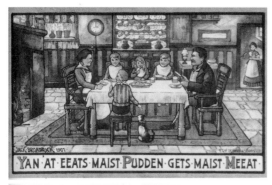

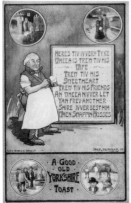

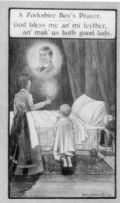

Yorkshire Arms, Toasts and Sayings
Three cards from the series published by E. T. W. Dennis by artist Jack Broadrick around 1907, which typify Yorkshire humour and philosophy. Nothing much has changed over the intervening century.

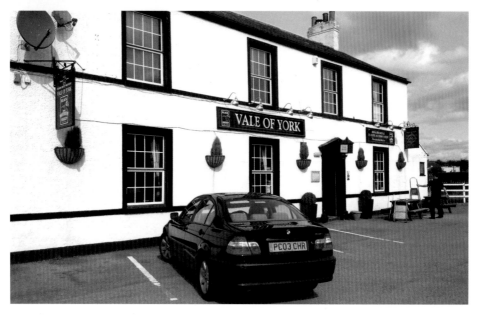

The Vale of York Public House
Located in Carlton Miniott, close to Thirsk Railway Station. J. L. Carr, the eccentric novelist, was born nearby in 1912 in one of the railway cottages where his father became stationmaster. Carr's works include *How Steeple Sinderby Wanderers Won the F.A. Cup*, *The Battle of Pollocks Crossing*, *A Month in the Country* and *A Day in Summer*.

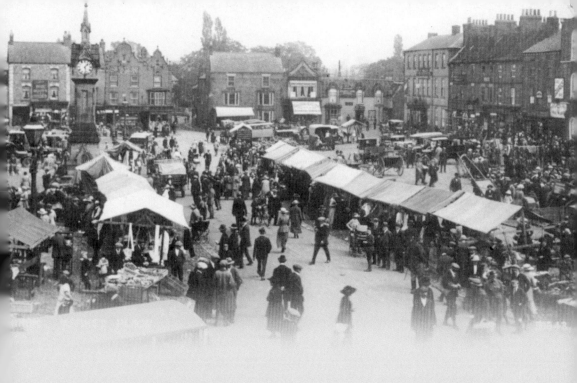

CHAPTER 1

In & Around Thirsk

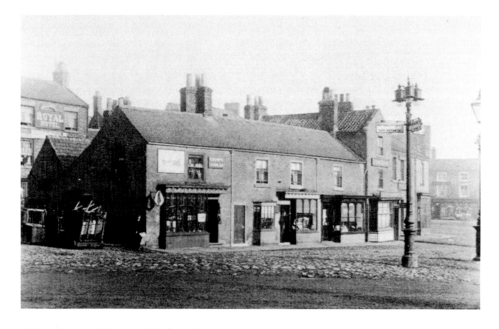

Thirsk Market Place and Bullock-Baiting

This 1905 photograph shows a row of shops in the middle of the Market Place, which were demolished to make way for the post office. W. Scott, saddler's, is the shop nearest to us, still trading but at the northern end. The Royal still towers behind. The cobbled area in the foreground is the old thirty-foot bullring where all bulls and bullocks had, by law until 1754, to be baited by dogs before they were slaughtered. Note the old gas lamp next to the newer electric lamp. The Quaker Bartholomew Smith & Son was reputedly the first draper's to be established in Britain in 1580; now unfortunately demolished. The 1920s Market Day photograph on page 5 looks towards the north-west corner of the Market Place. It originates before 1145 when the Lord of the Manor was able to exact tolls on the stalls.

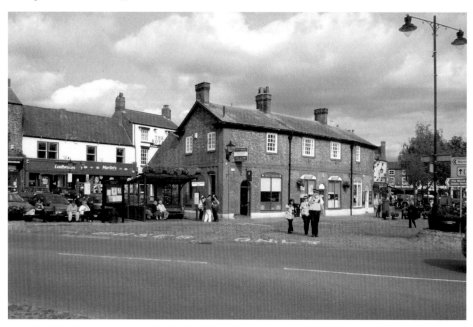

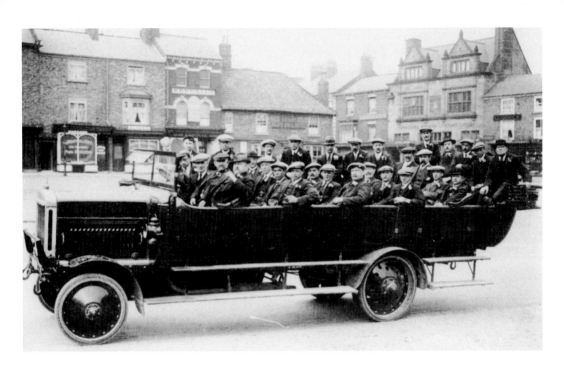

The Motor Car Age Dawns in Thirsk

Another view of the Market Place on what was obviously the start of a day out in a stylish charabanc, looking towards the Black Bull in the centre and what is now Barclay's Bank and the White Rose Bookshop. Note the solid tyres and fold-away hood at the rear. Cars are not such a rarity nowadays as the new image on page 5 shows.

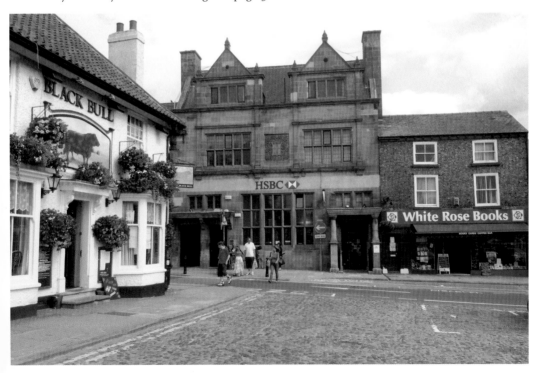

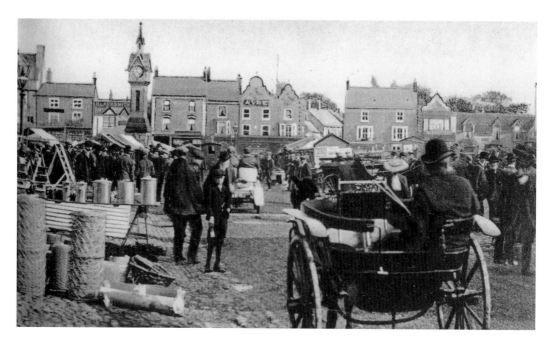

Thirsk's Clock and Princess Mary of Teck

The fine clock dates from 1896, set up in commemoration of the marriage between the Duke and Duchess of York (Princess Mary of Teck) who later became George V and Queen Mary. The finials on the face and the pinnacles have not survived. The clock shares its name with Thirsk Clock youth café and community centre, which reopened in 2010 in new premises behind St James' Green Methodist church.

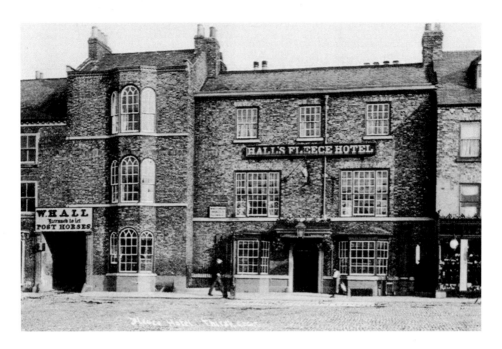

Hall's Fleece Hotel

Not that much has changed since the original photograph in 1890, apart from the name change to the Golden Fleece. Hall was William Hall who took over the inn at the age of twenty-one in 1839. At the time, it was one of sixteen public houses in the Market Place. On the other hand, there is precious little left of the tenth-century Thirsk Castle owned by Roger de Mowbray, as he surrendered it to Henry II in 1174 just before it was razed to the ground – Castle Yard is one of the few vestiges.

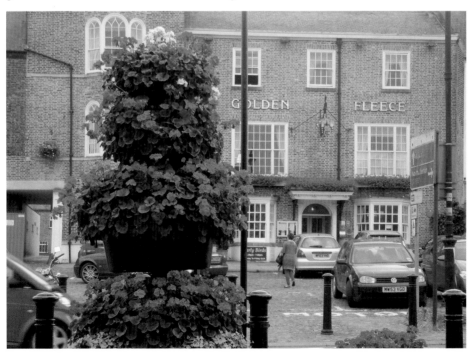

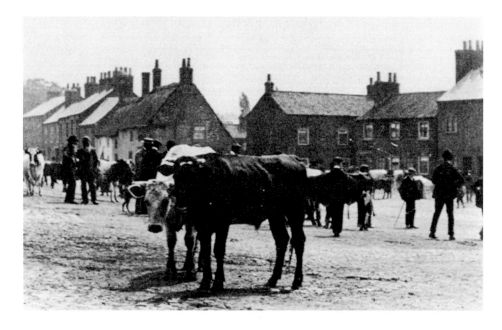

St James' Green and the Slaying of Henry Percy

This 1880 photograph shows the green – once the centre of town – as a cattle market, a function it performed for centuries until 1914. *Bulmer's 1890 Directory* lists five inns here: the Pheasant, the Rising Sun, the Wheat Sheaf, the Dolphin & Anchor and the Lord Nelson. The Nelson is the sole survivor. Henry Percy, 4th Earl of Northumberland, was slain here in 1489 by a mob outraged at Henry VII's announcement of further taxation. The pleasant and picturesque green is named after the St James' chantry chapel founded by William de Mowbray that once stood here.

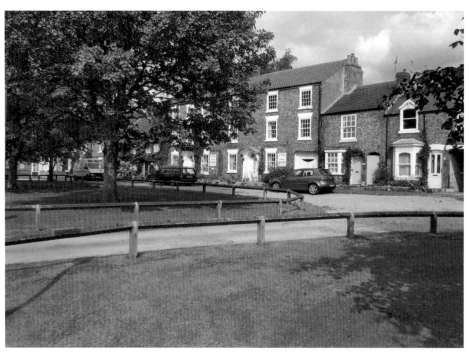

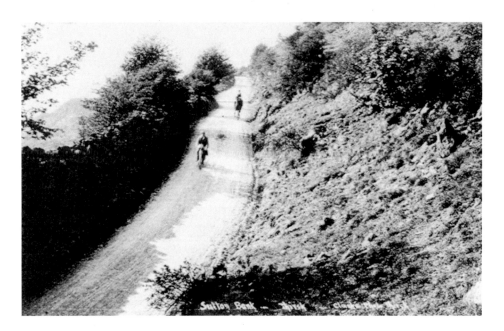

Sutton Bank

Sutton Bank forms part of the eastern edge of the Vale of York and, as can be seen here in this 1909 postcard, it has always been a popular drive for all modes of transport. The 1:4 climb with its hairpin bend was popular with motorcycle trials in the early twentieth century. It is the site of an Iron Age hill fort, built around 400 BC. More recently, the Yorkshire Gliding Club has been using it for ridge soaring since the 1930s. The modern photograph shows a misty Vale of York from the top of the Bank with Lake Gormire on the right.

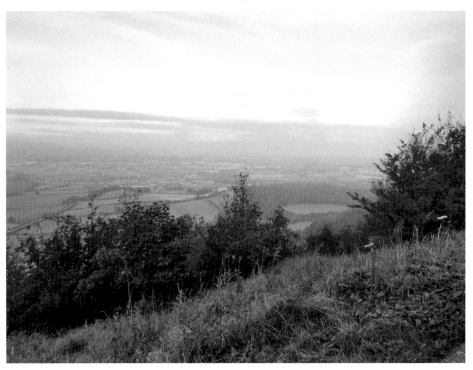

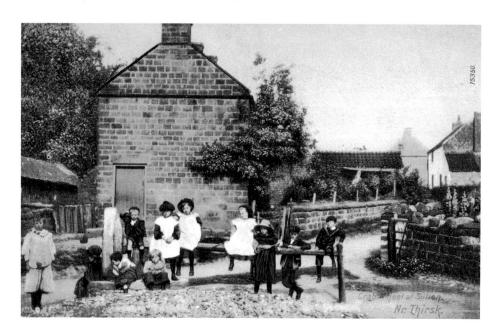

Sutton-under-Whitestonecliffe

With twenty-seven letters this is the longest place-name in Britain. The village is three miles east of Thirsk at the foot of Sutton Bank and named after nearby Whitestone Cliff. The crab wheel is in fact a four-foot burrstone or millstone, mounted over a grinding pedestal. It was, according to Edmund Bogg in his *Richmondshire and the Vale of Mowbray* (Leeds, 1906), 'where was made from crab apples the vinegar known as verjuice, an obsolete industry'. The manufacture of such stones is the origin of the saying that you can tell a hard-working man by his hands, which 'show his steel' – namely, the splinters of steel embedded in the stone-dresser's hands from the sparks. Verjuice is a very acidic condiment or sauce widely used in the Middle Ages and still used today in Iran and Australia.

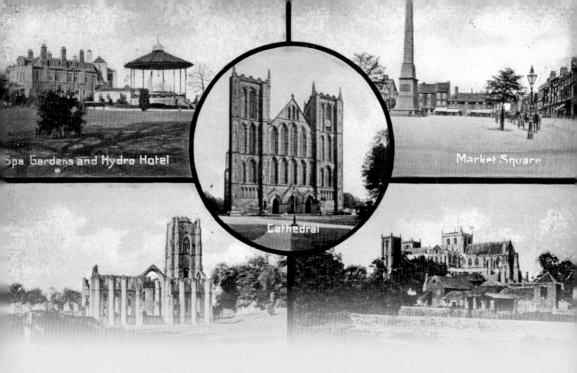
Spa Gardens and Hydro Hotel

Cathedral

Market Square

CHAPTER 2

In & Around Ripon

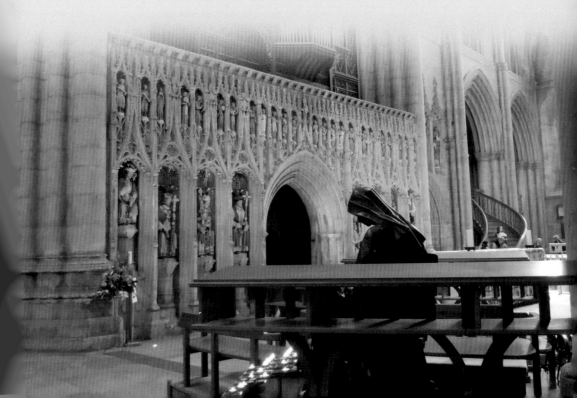

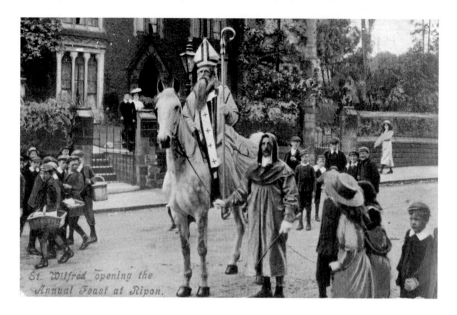

St. Wilfred opening the Annual Feast at Ripon.

St Wilfrid's Feast

Ripon's history starts some 230 million years ago, when the area formed an edge of the tropical Zechstein Sea; indeed, Quarry Moor has yielded evidence of contemporary rock formations. The Anglo-Saxons had settlements on Alicey Hill and the King of Northumbria established a monastery in the mid-seventh century. Things really got going locally, though, in 660 when the affluent St Wilfrid (who had held posts variously as Abbot or Bishop of Ripon, Hexham, Northumbria and York) took over and extended Ripon's reputation throughout Europe. The Feast of St Wilfrid's has been celebrated since the twelfth century when it was a four-day fair in April. The older picture is from around 1905; the newer one, and page 13, shows the screen depicting characters important to the history of the cathedral.

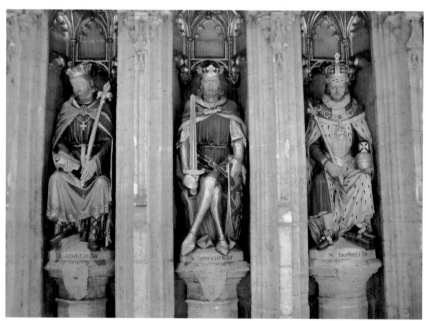

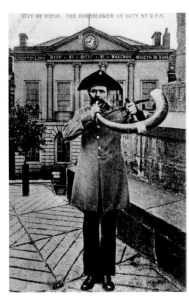

Bellmen, Hornblowers and Criminals

The Curfew Horn, unique to Ripon, has been blown each night by the Wakeman since the thirteenth century to 'set the watch'. The ceremony still takes place at the four corners of the obelisk and at the mayor's house. It was originally blown at the mayor's house and then the town hall, but reversed in 1913 so that spectators might catch the 9.29 to Harrogate. The Wakeman also hired constables to help keep order in the city. The office of Bellman dates from 1367, and ever since he can be found ringing his bell at eleven o'clock every Thursday morning in Market Square to open the now defunct corn market. He was empowered to levy a toll on each sack sold (the Market Sweepings), to start the Quarter Sessions and inflict whippings on law-breakers. All householders had to contribute to the cost of this service – twopence for each outer door of their house per annum. The modern picture shows two 'criminals' waiting in the cells below (the holding box) to go up to the courtroom (now the Courthouse Museum).

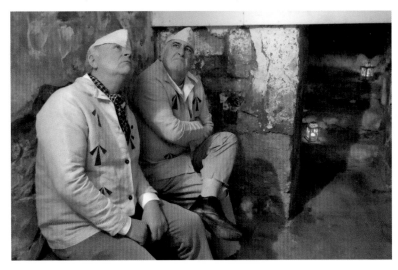

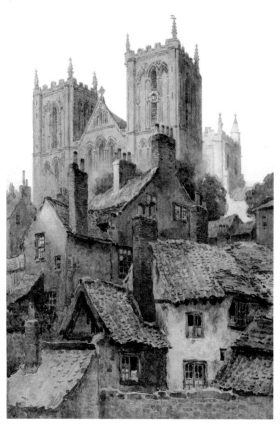

Ripon Cathedral
A view from York Yard on Bedern Bank, somewhat romanticised by artist E. W. Haslehust (1866–1949) in the *Ripon and Harrogate* volume of *Beautiful Britain* by R. Murray Gilchrist – it obviously does not show the slum conditions that persisted here until demolition. The Early English west front, as seen on page 13, was built in the early thirteenth century by Archbishop Walter de Grey of York and is characterised by the rows of lancet windows. The twin towers sported timber spires, which were removed in 1664. The pinnacles were added in 1797 but removed in 1940.

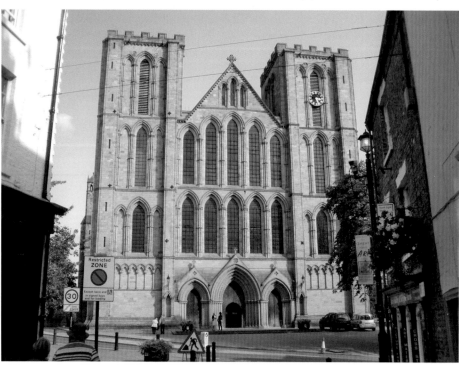

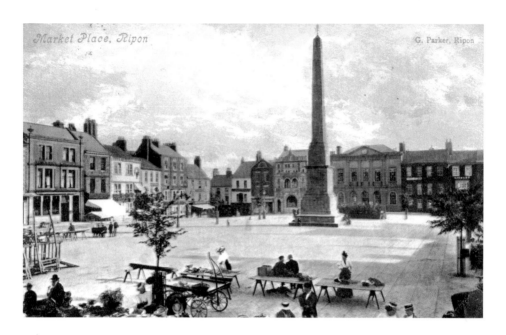

Market Place and the Obelisk

Market Place is dominated by the 1702 obelisk and, at ninety feet, is the oldest freestanding monument in the country. The top is adorned with a star and horn, which symbolise Ripon's ancient crafts and customs. The four small obelisks that stood at the four corners of the base were removed in 1882. Ripon is Britain's oldest city, having been granted a charter by King Alfred the Great in 886 and presented with a horn as a symbol of the charter. The older picture is from 1904. Ripon is also notable for being a liberty with independent county jurisdiction under the jurisdiction of the Archbishop of York granted by King Aethelstan in the tenth century. Until 1836 it was governed by a high steward and its own justices of the peace with separate quarter sessions.

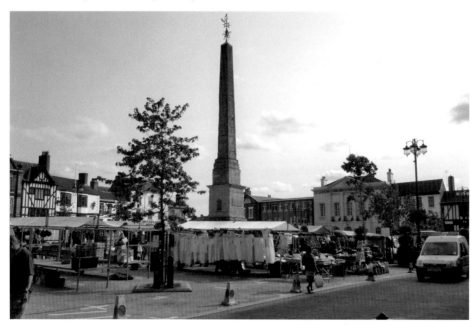

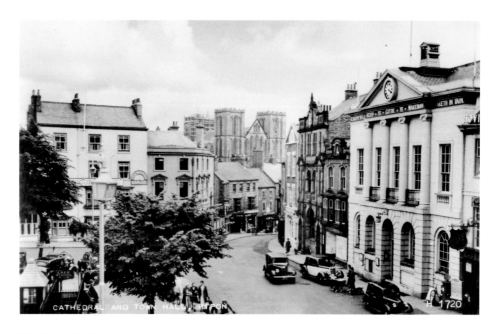

The Town Hall

Built in 1801, the impressive town hall comprised assembly rooms, a committee room for public meetings and the magistrates' court. The clock was added in 1859 as a gift from the Horticultural Society; the text of the inscription added in 1886 is from Psalm 127: 'Except ye Lord keep ye City ye Wakeman Waketh in vain.' The café on the extreme right was once the post office, then Alves the florist's, and later the Lawrence Ballroom. The Unicorn can be seen across the Market Place.

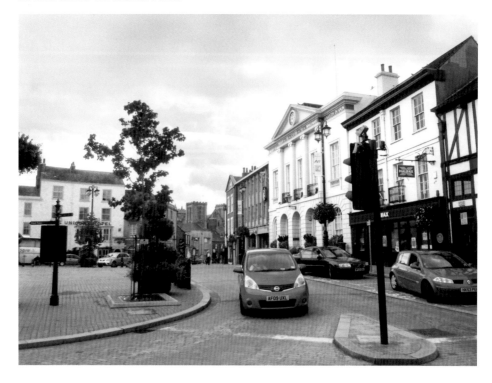

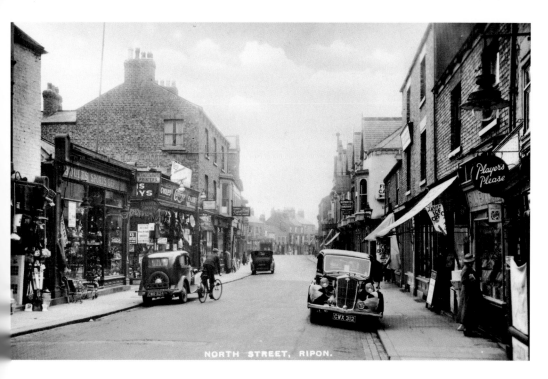

NORTH STREET, RIPON.

North Street

A fine shot of North Street (or Horsefair until the nineteenth century) showing Boult's Sports depot, Metcalfe's the printer and Curry's cycle and radio shop on the left. Curry's also sold Brock's fireworks and leather goods as the signs show and went on to specialise in electronic goods. On the right is the St Wilfrid's Hotel, purveyors of Ripon Ales.

LIBERTY of RIPON

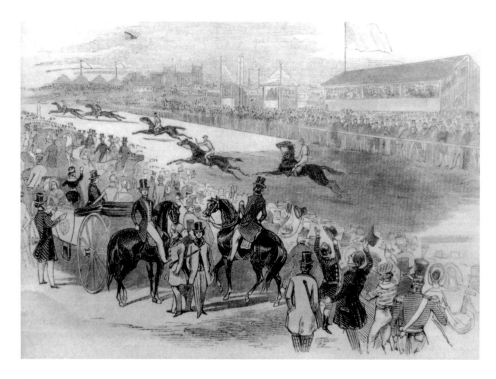

Ripon Races

There has been racing at Ripon since 1664 on Bondgate Green. In around 1717, one meeting a year took place at High Common. Ripon is reputed to have been the venue for the country's first ladies' horse race in 1723. The local MP's wife, Mrs Aislabie, was the winner. After a pause from 1826, racing resumed in 1837 until 1865 when the Whitcliffe Lane course opened only to be superseded by Boroughbridge Road in 1900, popularly known as Yorkshire's Garden Racecourse. Ripon's most valuable race is the Great St Wilfrid's Stakes.

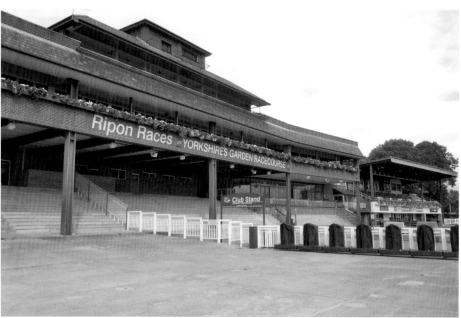

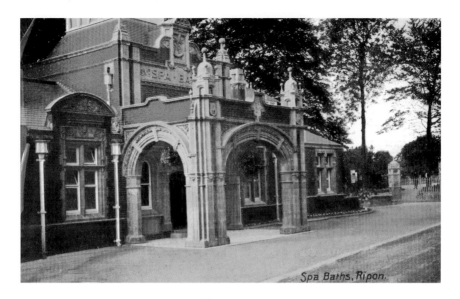

Spa Baths, Ripon.

Ripon Spa Baths

Built in 1905 in Park Street, the entrance to the Spa gardens is on the right, with the Spa Hydro – now Spa Hotel – beyond. Entrance in the early days was 1*d*, a glass of water a further penny. Old Boots (see page 26) was not Ripon's only ugly inhabitant; Nanny Appleby ran him a close second with her hairy warts, bad teeth and bulging eyes. Regarded as a witch but more of a quack, she was attending a sick boy one day, harassed and heckled as usual by the abusive Tom Moss. Nanny Appleby opened the boy's mouth only to see a grinning demon, which had taken refuge in the boy's stomach: it flew out when she poured holy water down his throat and flew straight into Tom Moss's mouth and into his stomach where it tormented him so badly that he resorted to the lunatic asylum and then the River Ure in which he drowned.

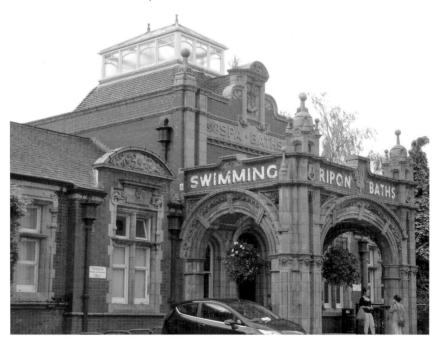

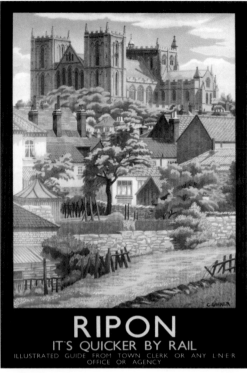

Come to Ripon – England's Last Spa

The pump room and *porte-cochere* (to shelter arriving gentry) are unique in that they are the only spa buildings in Britain to have been opened by a member of the royal family; namely Princess Henry of Battenberg, Queen Victoria's youngest daughter. The waters are piped in from the sulphur springs at Aldfield village four miles away. 'Craftsmen of national repute made stained-glass windows. The city paid extra to have pomegranates carved on the mahogany doors and a faience river god on the pump room wall, with the end of the Aldfield pipe gushing from his mouth', said the *Guardian* in April 2008, reporting on the successful battle to prevent the conversion of the building – a swimming baths since 1936 – into offices and flats. The old picture is a LNER poster from around 1930 based on a painting by Charles Ginner (1878–1952), famous for his paintings of town and landscapes, many of which hang in the Tate. The new picture shows the beautifully preserved foyer to the spa baths today.

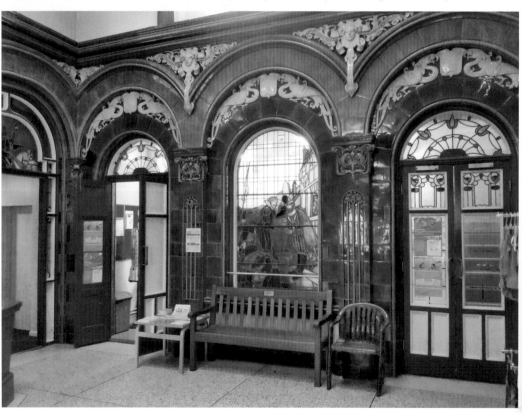

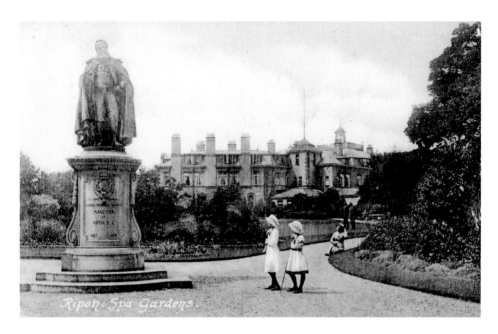

Spa Gardens in 1926

The Spa Hydro in the background here was the response in 1906 to demand for hotel rooms after the opening of the spa. The statue being so earnestly observed is of the Marquis of Ripon, unveiled in May 1912, three years after he died. The Marquis was born in 1827 in 10 Downing Street, the son of Frederick John Robinson, 1st Earl of Ripon the then Prime Minister, who went on to hold high office in the Liberal Party. In addition he was Mayor of Ripon 1895–96 and Viceroy of India 1880–94.

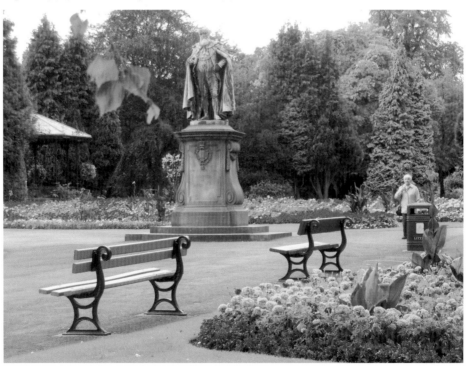

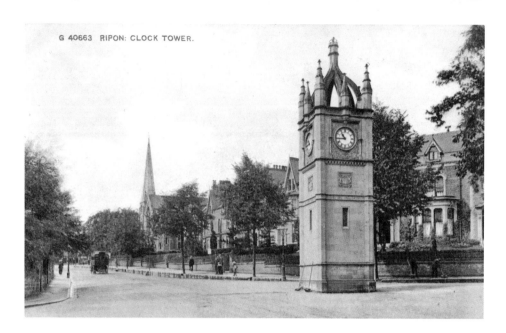

Ripon Clock Tower

The statue of Queen Victoria above the doorway on the 43-foot clock tower in North Road gives us the reason why it was built – to mark the queen's Diamond Jubilee in 1897. An eight-ribbed ogee crown with a pinnacle at the base of each forms the top with a metal crown surmounting that. The Congregationalist church in the background was opened in 1870 and closed 100 years later to be demolished and replaced by flats. The old photograph is from around 1909.

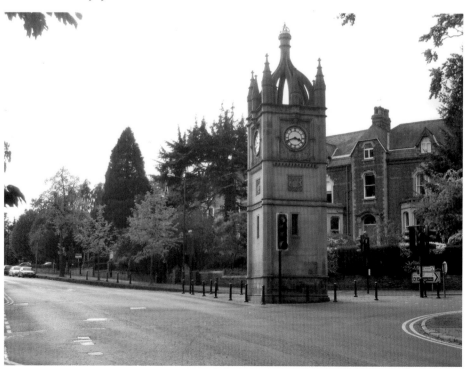

CHOLERA.

Humiliation and Prayer.

TO THE

INHABITANTS OF THE BOROUGH OF RIPON.

Confident of your sympathy with me in the feeling that a season of Public affliction especially calls for the observance of the great Christian duties of Humiliation and Prayer, I beg leave to recommend the CLOSING of SHOPS, and PLACES of BUSINESS within the Borough, *on Wednesday next, the 26th Inst.*, (the day recommended by the Lord Bishop of the Diocese, for Religious observance) from half-past Nine o'clock in the Morning till One o'clock at Noon, and from Six o'clock in the Evening for the remainder of the day, in order to afford opportunities for *Public Worship, and Private Devotion.*

THOS. WILLIAMSON, MAYOR.

Ripon Poor Law Union

ON ENTERING THE WORKHOUSE, YOU WILL BE CONFINED TO THE DAYROOMS, SLEEPING WARDS AND EXERCISE YARDS OF YOUR CLASS.

YOU MUST NOT TALK WITH OR COMMUNICATE WITH ANYONE OF A DIFFERENT CLASS.

YOU MUST NOT BRING INTO THE WORKHOUSE ANY SPIRITUOUS OR FERMENTED LIQUOR.

4 and 5 William 4 c. 76

Ripon Workhouse

These fascinating posters are on display in the Workhouse Museum, part of which now occupies the male vagrants' area of the workhouse, which was built in 1855 and included fourteen lock-up cells. In the beginning Ripon had thirty-three inmates: eleven men, eleven boys, nine women and two girls. Able-bodied men spent eight hours every day breaking stones for road repairs. The workhouse had its own teacher, chaplain and doctors, grew vegetables in the gardens (still cultivated today), had its own infirmary and a van to take lunatics to local asylums if they became violent.

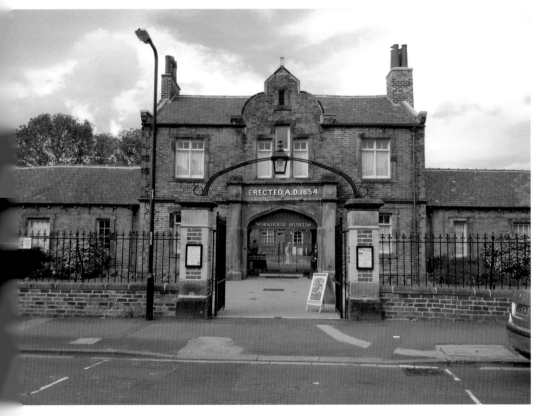

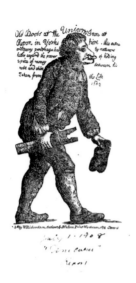

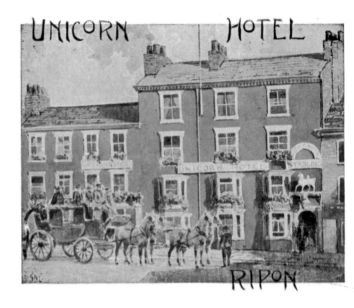

The Unicorn Hotel and Old Boots

Tom Crudd, alias Thomas Spence or Old Boots, worked at this coaching inn as boot boy greeting travellers on the stagecoaches and private carriages. He was something of a star, offering entertainment as well as boot-jack or boot-pull and slippers; his turn was holding a coin (proffered by a guest) between his nose and chin, as shown here. Tom kept the coin.

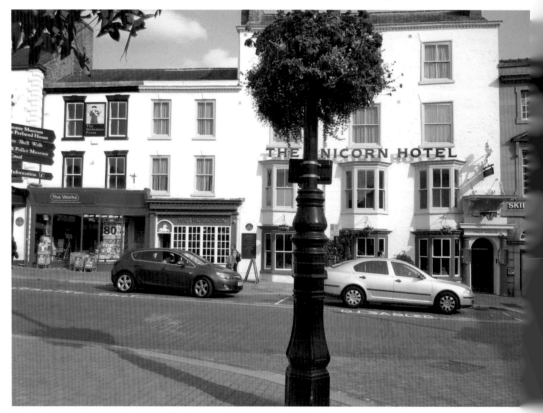

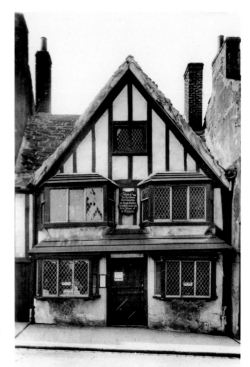

Wakeman's House

This is often described – inaccurately – as the home of Hugh Ripley, Ripon's last Wakeman and its first Mayor in 1604. It was physically turned round in 1600 to face the square and is one of the very few surviving oak timber-framed (with wattle and daub infill) buildings surviving in Ripon. It narrowly escaped demolition after the Second World War.

27

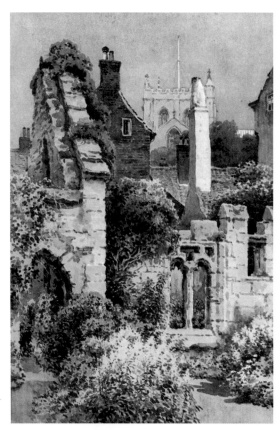

St Anne's Chapel

Part of St Anne's Hospital, the remains in St Agnesgate of the chancel or chapel are all that is left of this ancient almshouse; the nave which housed the Hospital itself was demolished in 1869 and the almshouses were built. St Agnesgate derives from St Anne's Gate and is referred to as Annesgate in 1228. There are records of the hospital from 1438, but it is undoubtedly somewhat older. Founded by one of the Nevilles, it supported and housed eight poor widows in two dormitories of four beds with two common beds, all overseen by a chaplain. The Ernest Haslehust painting was first published in R. Murray Gilchrist's *Ripon and Harrogate* (Blackie & Son Ltd, 1914).

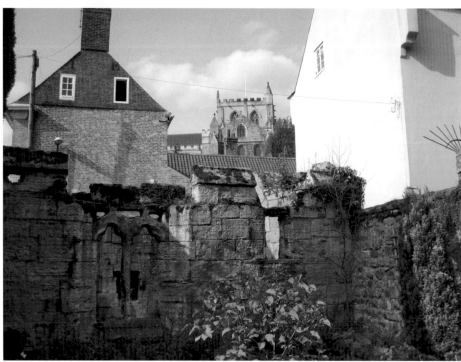

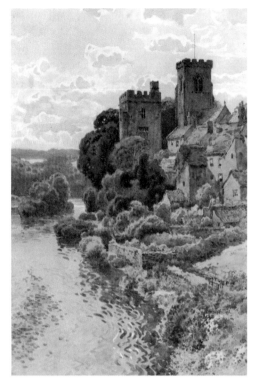

West Tanfield: Marmion Tower and St Nicholas' Church

This Haslehust illustration captures the beauty of the place. The Marmion Tower – the gatehouse of the Marmions' manor house – is on the left, and is all that remains of the fifteenth-century manor house. St Nicholas' church contains tombs of the Marmion family, including Robert de Marmion (1345–67) and Laura St Quintin, his wife. The Marmions were descended from the Gernegan de Tanfields, according to Camden.

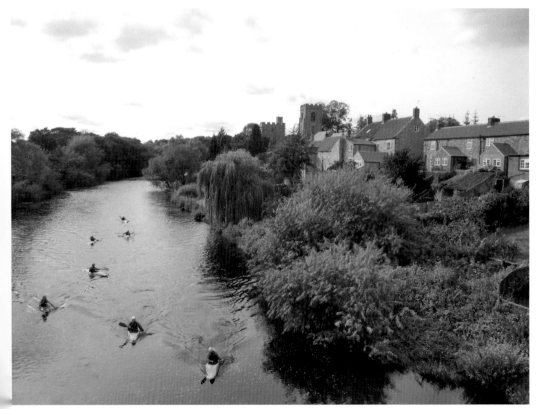

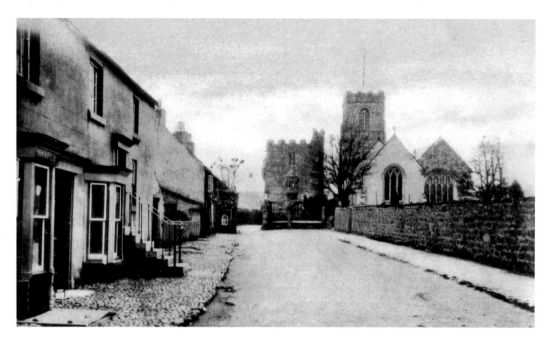

'One of the most charming [views] in England'

R. Murray Gilchrist, in his *Ripon and Harrogate* volume of *Beautiful England* says of this village, 'Of all the places of interest near Ripon none exceeds in loveliness the village of Tanfield. The view from the bridge over the Ure is one of the most charming in England...a wonderful harmony of rich colour.'

CHAPTER 3

In & Around
Boroughbridge

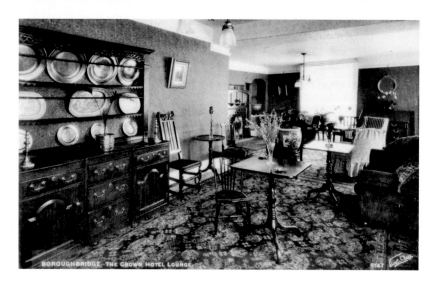

Boroughbridge

The Romans built a fort near to where the Devil's Arrows are to defend a crossing of the River Ure. The Normans moved this wooden bridge to its present site in the late eleventh century and it was eventually rebuilt in stone in the sixteenth century. A plaque tells us that the downstream side dates from 1562 and the upstream from 1784 after it had been widened. In 1318 and 1319 the town was devastated by marauding Scots, and at the 1322 Battle of Boroughbridge (1322) Sir Andrew Harclay defeated the Earl of Lancaster who took refuge in the old church on St James's Square. Notwithstanding, Harclay took Lancaster prisoner and had him tried and beheaded as a traitor at York. Harclay was elevated to Earl of Carlisle but turned against Edward and was himself beheaded in 1323. His name lives on in the Harclay Bar in Rose Manor Hotel. The Crown Hotel is on the extreme right of the modern picture, which also shows the Three Greyhounds.

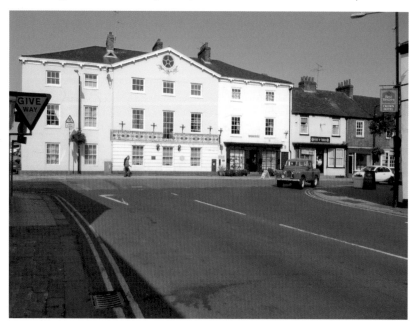

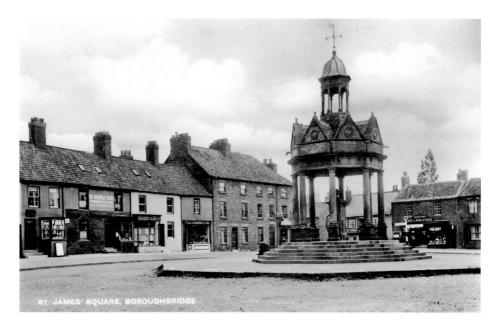

St James' Square

This fine market square has witnessed much of the history of Boroughbridge. The town's second national school was here from 1832 until 1854 when the building was sold at auction to the Conservative Association (see page 35) – now the town library – as were the lock-up and the stocks. The medieval St James's church was demolished in 1851 (see page 39), and in the next year the Battle Cross commemorating the Battle of Boroughbridge was moved from the square to Aldborough. The fountain that was built over an artesian well in 1875 was the town's main source of water.

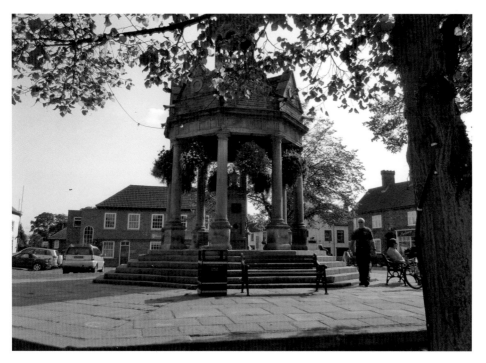

33

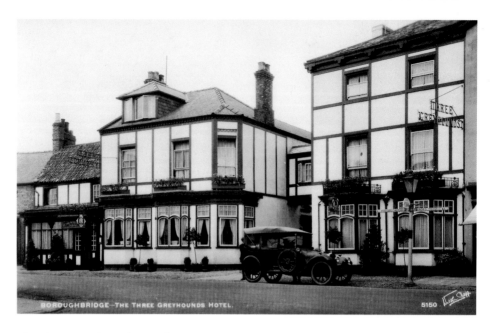

BOROUGHBRIDGE—THE THREE GREYHOUNDS HOTEL. 5150

The Three Greyhounds Hotel

Next to the post office on Horsefair, and now converted into flats, the Three Greyhounds coaching inn was known for its Whig affiliations while the Tories patronised the Crown opposite. The Three Greyhounds was once the home of the Mauleverer family, and you can still see the three greyhounds taken from the Mauleverers' coat of arms (see page 39). In 1569 the Crown was Boroughbridge MP William Tankard's manor house and was used as a rendezvous for the Council of the North where the Earls of Northumberland and Westmoreland conspired to set Mary Queen of Scots on the throne.

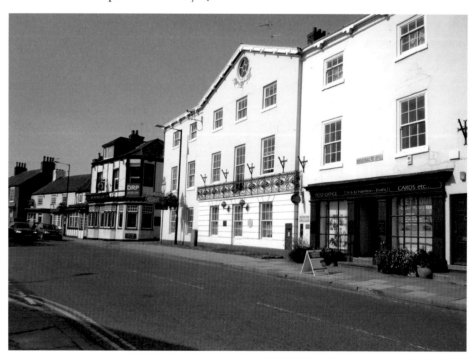

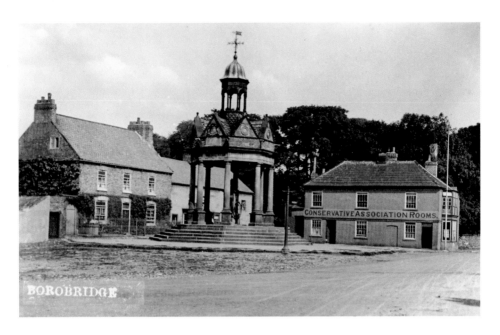

The Conservative Association Rooms

Boroughbridge is a typical market town and seems always to have been – it is equidistant between Edinburgh and London and has benefitted from its position as a staging post on the Great North Road. In its heyday as many as 2,000 cattle a day were driven across the bridge here *en route* from Scotland to southern markets. The drovers and other road and river travellers had twenty-two inns to choose from for rest and refreshment for themselves and for their horses; river cargoes included lead, wine, spices and linen. Horse traders and gypsies came to the Barnaby Fair. You can still see a guillotine for cutting iron in Horsefair on the site of the blacksmith's and a wheel plate set in the pavement. The fourth Devil's Arrow was used in the building of Peggy Bridge, and the white cottages in Hall Square (see page 31) were originally fishermen's cottages.

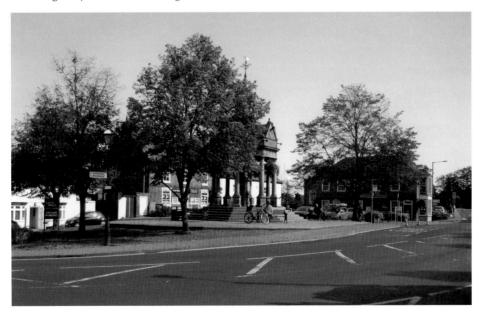

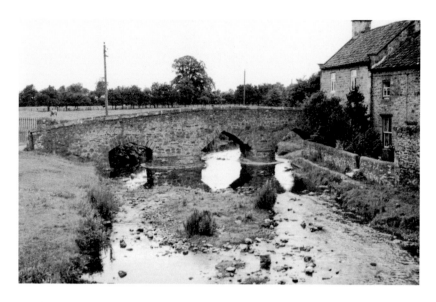

Isurium Brigantum

Isurium Brigantum is the Latin name for the Roman town of Aldborough, established in the middle of the second century AD and one of the northernmost settlements in the Roman Empire. The *Brigantum* part of the name refers of course to the native British tribe, the Brigantes, who dominated much of northern England before the Romans arrived. *Isurium* is probably the British name for the River Ure. Most of the town still awaits excavation but a part of the walls and two mosaic pavements can be seen at the museum. The famous star or flower mosaic is *in situ* and on page 31, while the fine Romulus and Remus mosaic is in the Leeds City Museum. The new photograph shows St Andrew's church on the left and the Ship Inn public house on the right. It takes its name from the river traffic through the town and dates back to before 1671, as evidenced by a copper token, dated 1671, depicting a ship in full sail with the inscription 'John Briggs in Aldborough his half penny'.

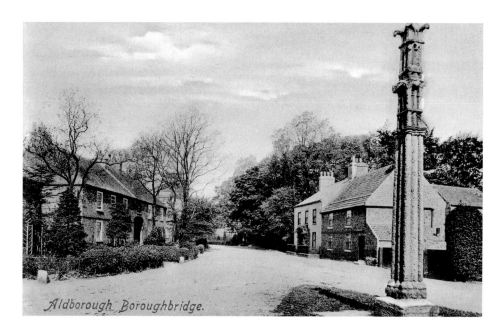

Aldborough Boroughbridge.

Aldborough Battle Cross

As we have seen, this eighteen-foot fourteenth-century monument to the Battle of Boroughbridge was moved from to Aldborough (Old Borough) in 1852. The battle in 1322 was a resounding victory by Edward II (represented by Sir Andrew Harclay) over the rebellious barons under the Earl of Lancaster, numbering approximately 4,000 royalists and 700 plus rebels. Harclay's tactics – a defensive wall of spears and an offensive arrow storm – anticipated Edward III's tactics and famous victory against the French at Crécy in 1346.

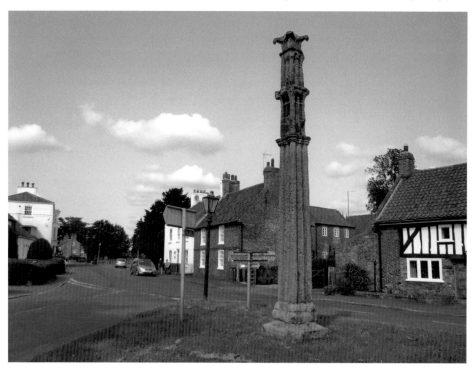

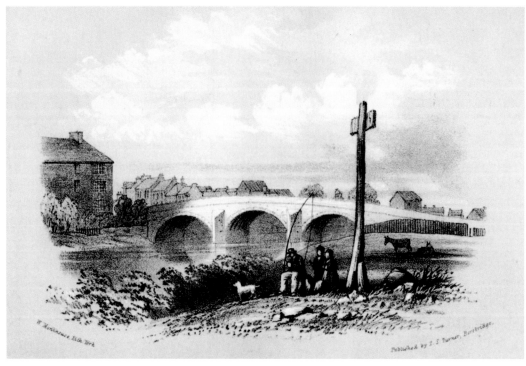

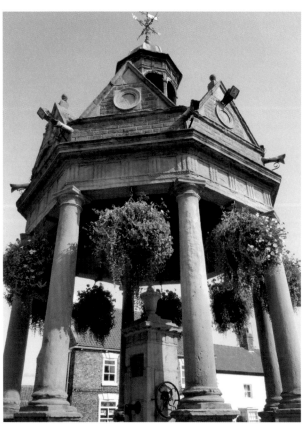

Boroughbridge Bridge

Superseding a wooden bridge that was built soon after the Norman Conquest, Boroughbridge Bridge was formerly the boundary between the West and North ridings and jointly maintained by both counties. The lithograph is by W. Monkhouse of York and was published by T. S. Turner of Boroughbridge in his *History of Aldborough and Boroughbridge* in 1853. Tolls were paid, strangely, to the Earl of Chichester. The new photograph shows the water pump in the Market Square.

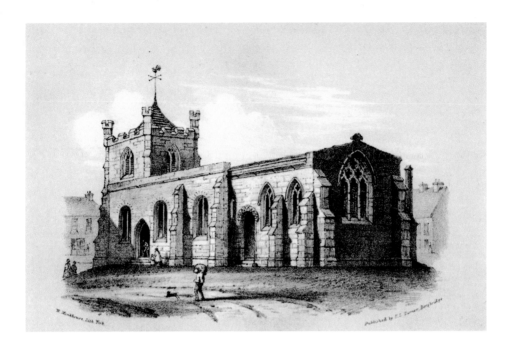

The Old Church, Boroughbridge

Another Monkhouse lithograph showing St James's church, which stood in the Square and was demolished 4 July 1851 on the grounds that it was too small – it only seated 130 worshippers. It was superseded the following year by the new St James's church in Church Lane. The three greyhounds, part of the Mauleverers' coat of arms, are shown in the new picture on the façade of the former Three Greyhounds Hotel.

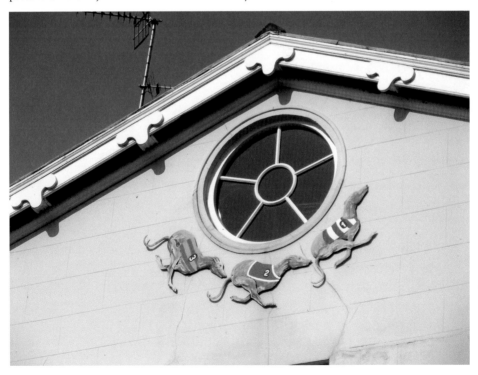

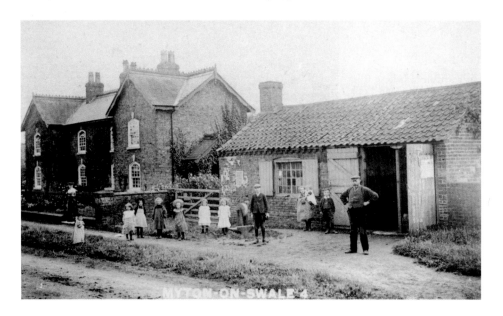

Myton-on-Swale

Myton, on the confluence of the Swale and Ure (thus forming the Ouse), is famous for three things: the White Battle or Battle of Myton Meadows in 1319, Myton Bridge, built in 1868 and Sir Miles Stapylton, one of the original Knights of the Garter. In the fourteenth century Sir Miles Stapylton killed a Saracen chief in front of the Kings of England and France, and took the Saracen's head for a crest. You can still see this on some of the houses in the village. In 1319, 12,000 Scots under the Earl of Moray headed for York, devastating everything in their path. They were finally confronted by a motley force of 10–20,000 clerics and villagers who were massacred or drowned in the rivers. Over 4,000 died – many of whom were ecclesiastics dressed in white robes, thus leading to the conflict taking the name, the 'White Battle'.

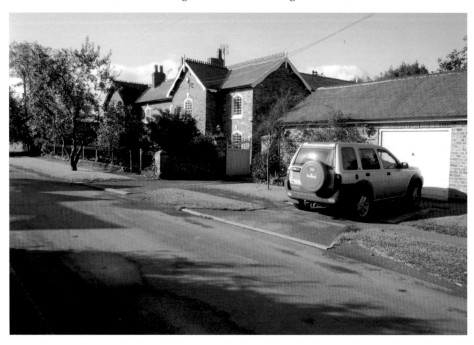

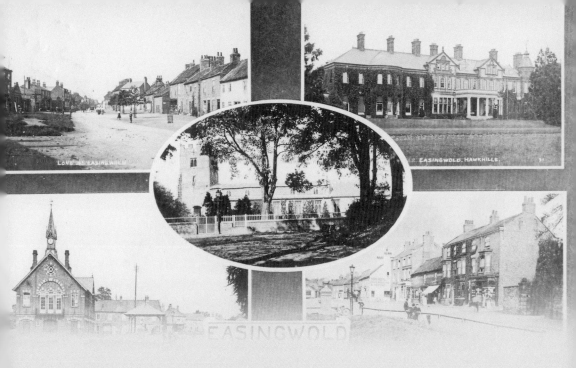

CHAPTER 4

In & Around Easingwold

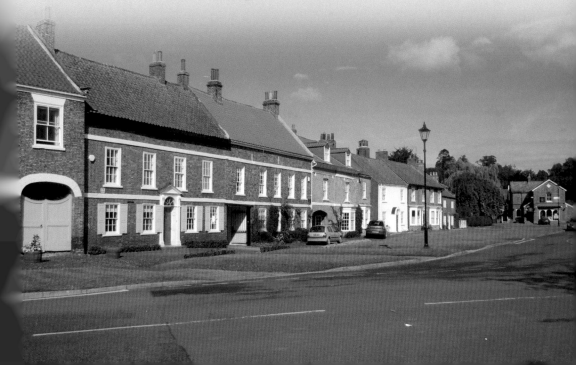

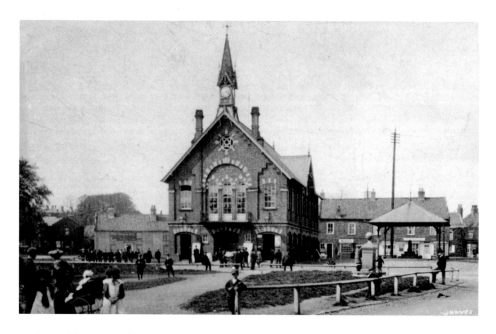

Easingwold Town Hall

The imposing town hall opened on 31 March 1864 at a cost of £1,423 and became the venue for the county court and petty sessions; the clock came later in 1869. The Bulmer West Highway Board met there to oversee road and street construction. In 1872 the chairman was one John Coates of Peep o' Day and it was he who oversaw much work on the roads to and from Oswaldkirk, Stillington and Sutton-on-the-Forest. Peep o' Day was the name of a farmhouse near Husthwaite about a mile and a half from Easingwold. The older pictures on page 41 are from around 1920.

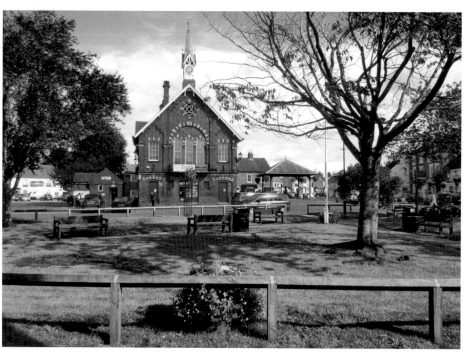

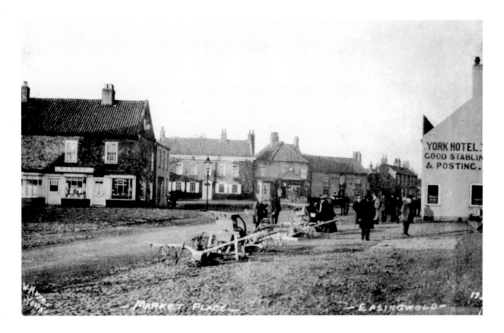

The York Hotel

The York (the White House) is on the right with the George out of shot down the Market Place from where William Hayes took this shot. The shop across the square is W. A. Fish with Reynard's ironmonger's and bicycle shop, and the Angel Hotel on the corner of Spring Street. Frank Reynard is the grandfather of Adrian Reynard, motorcycle and racing car driver and racing car builder.

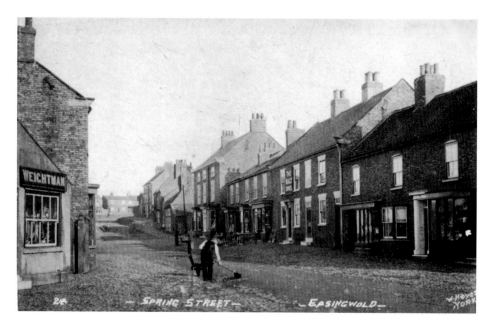

The Malt Shovel and the Angel

Looking up Spring Street from Market Place, with the Malt Shovel on the right and the Angel on the left. Charles I granted a charter to George Hall in 1638 by Letters Patent from which a free market could be held every Friday, with a cattle market every other Friday from St Matthew's Day to St Thomas's Day, along with two fairs each year (6 July and 26 September). In the 1820s, Easingwold supported twelve public houses, a number that later rose to twenty-eight, ten of which were in Long Street and four in Market Place; in the 1930s there were still nineteen.

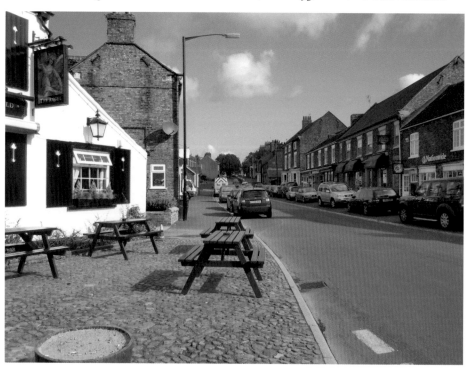

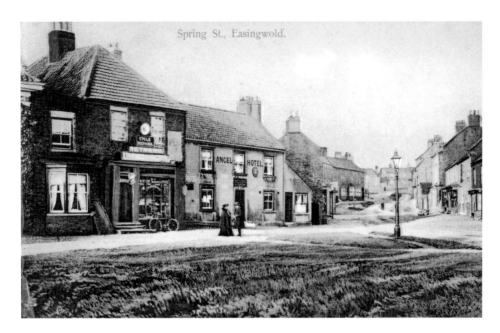

Spring St., Easingwold.

Spring Street

A closer, somewhat earlier shot of Reynard's clearly showing their cycle repair and a Dunlop tyre sign. Reynard's later became a garage and then a bus company. Few of Easingwold's timber-framed thatched houses have survived, although one fine example can be seen still in Uppleby with close studding and diagonal braces at the first floor level (see page 58). In Spring Street, a once-half-timbered house bears the inscription, 'God with us, 1664' – Parliamentarian rallying cry at Marston Moor.

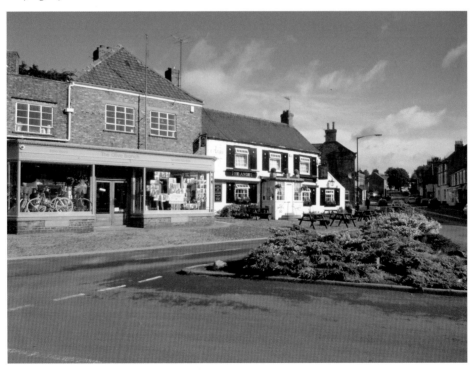

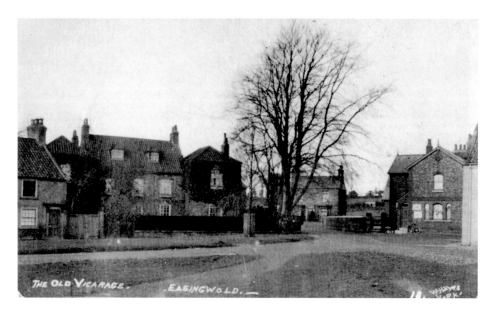

The Old Vicarage

This is the 1884 vicarage to the parish church of St John the Baptist and All Saints on Church Hill. The Domesday Book mentions a church and a priest in the town, although most of it dates from about 1400. The fine lych-gate was taken from Huntington parish church, north of York. The vicarage is in the gift of the Bishop of Chester, 'with residence and [in 1890] 30 acres of glebe'. To the right is the National School, which flourished from 1862 and included in its intake seven boys and girls from poor families who were provided with free education. It now houses the library. The uncompromising inscription above the main door reads 'Learn or Leave', although the Compulsory Education Act prohibited such a choice.

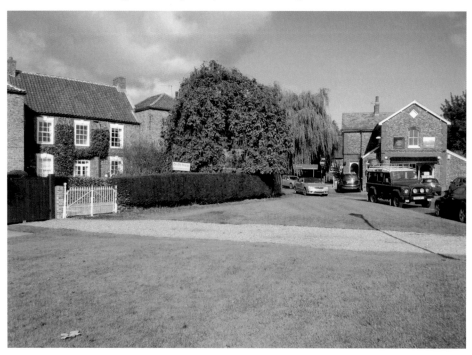

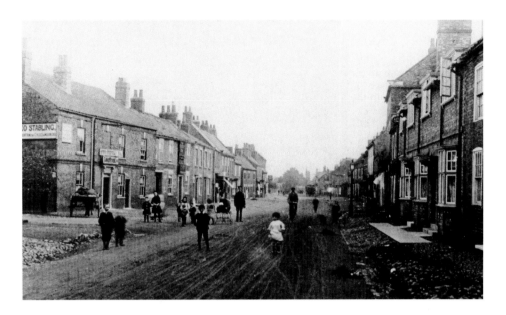

Long Street

A typical 1920s audience for the photographer, with a view showing a traffic-free Long Street (also once called Low Street). Looking south, we see children playing, babies in prams looked after by older sisters, a soldier, cart and cyclist. The buildings are still very much the same with the two pubs – the Bay Horse on the left and the Fleece next door but one – surviving as private houses, which now bear the names of the original pubs. The Catholic church in Long Street is St John the Evangelist, designed in 1830 by the architect Charles Hanson, the brother of York's Joseph Hanson – he who developed the 'Hansom cab'.

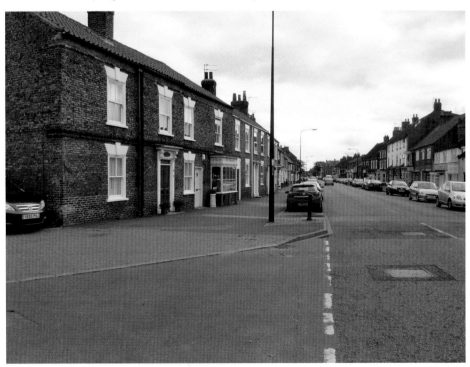

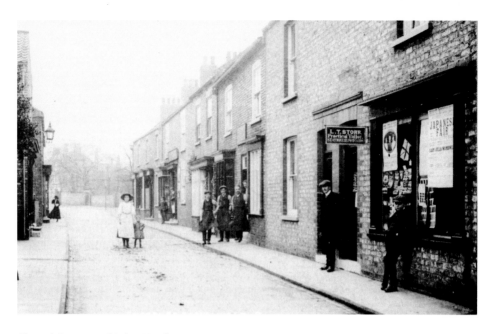

Chapel Street and John Wesley

Today's Methodist church here dates from 1975 and is the third chapel on the site, the first built in 1786 and the second in 1815, costing £970. In 1860 a school was added. John Wesley probably preached here on 8 May 1786, spending the night at a farm on the way to Stillington. The shop on the right here is L. T. Storr's 'practical tailors' stationer's and postcard seller's, now a private house.

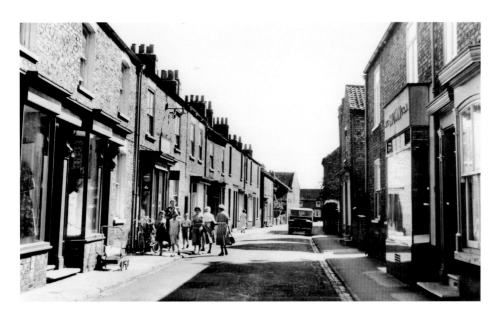

Chapel Street Around 1965

Domesday tells us of Easingwold in 1086: 'In Easingwold are 12 carucates of land to the geld, which 7 ploughs could plough. Morcar held these as 1 manor tre. Now it is in the king's hand, and there are 10 villans having 4 ploughs. [There is] a church with a priest... woodland pasture 2 leagues long and 2 broad. All together 3 leagues long and 2 broad. Then worth 32l; now 20s.' The devaluation can be accounted for by the devastating impact of the Harrying of the North.

All Change at Easingwold

Easingwold Light Railway opened in 1891 as a single-track branch line from Alne. It was the UK's smallest and the last privately owned railway in the country, opened in 1891. It carried passengers (nine trains in each direction on weekdays and a Saturday night special to and from York) and goods – the former until 1948 and latter until 1957. There was a staff of twelve in the early days. The first train was known as the *T'Awd Coffeepot* on account of the shape of its engine. The track was taken up in 1960 and all that remains is the Station Hotel after a devastating fire in 1967. The 'old' picture is David Weston's *All Change at Easingwold*. The hotel in the new picture shows the hotel as a private dwelling today.

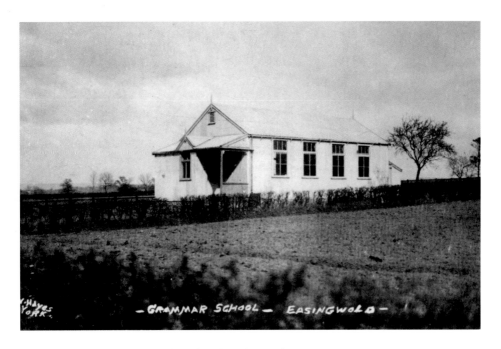

Easingwold Grammar School or the Tin Tabernacle

Easingwold's primary school on Thirsk Road now stands where the grammar school, built in 1911, once did. The first school here was the 1905 Tin Tabernacle, a site chosen because it was close to the railway station. The replacement 1954 Comprehensive School on the York Road caters for around 1,400 students and is a Specialist Language College. The grammar school was originally endowed in 1781 as a free school by a Mrs Eleanor Westerman.

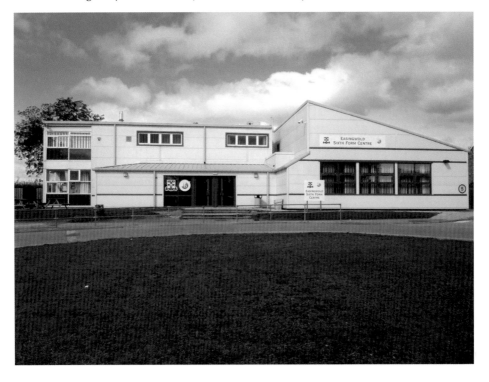

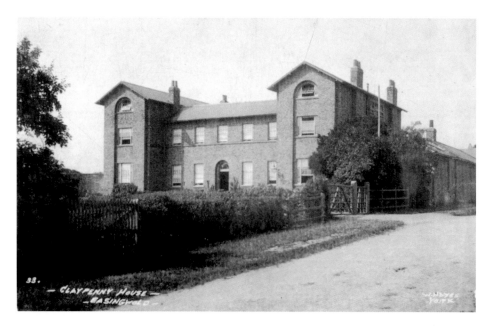

Claypenny Hospital and the Old Workhouse

The hospital buildings have been converted into Cedar Place, a twenty-two-property complex comprising flats, houses and bungalows. Founded in 1932 as the Claypenny Colony for psychiatric patients, its name changed in 1952 and it closed in 1993. It was developed on the site of the redundant Easingwold Poor Law Institution (the workhouse), which dated from the 1830s. Patient numbers increased from 90 in 1937 to 188 in 1938 and reached a peak of around 360 in the mid-1950s – the hospital always had a reputation for overcrowding. The numbered and lettered wards were renamed with tree names in the 1950s, as reflected today in Cedar Place, to make the place more 'humane'.

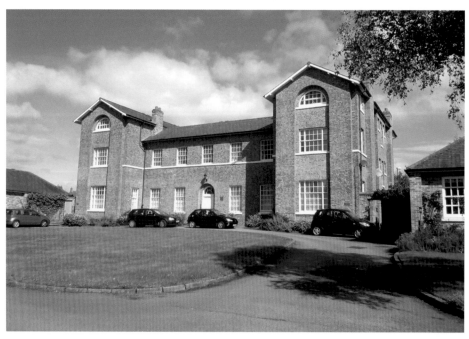

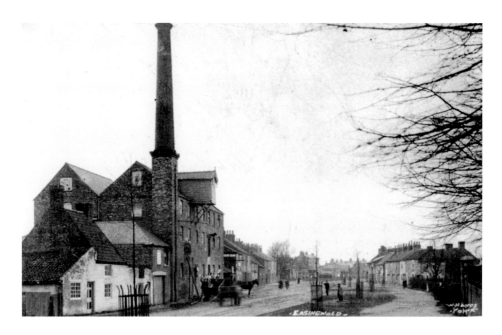

Flour Mills in Long Street

The Union Steam Flour Mill was opened in 1856, the same year as it was decided to adopt the Lighting and Watching Act of William IV to enable gas lighting for the town, leading to the opening of the Easingwold Gas & Coke Company with its gasworks in Long Street the following year. The Union Mill was probably responsible for the demise of the tower windmill on Mill Street, which may have been used both as a corn mill and a mustard mill at one time or another. Other industries in the mid-nineteenth century included an iron foundry, brewing, rope walks, a tannery, and brick-making, with a healthy trade in bacon and butter. Today the site is occupied by a supermarket.

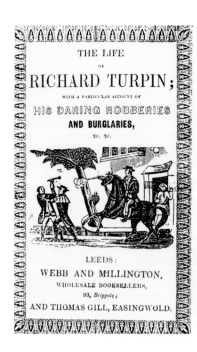

Vallis Eboracensis

COMPRISING

THE HISTORY AND ANTIQUITIES

OF

EASINGWOLD

AND ITS NEIGHBOURHOOD

BY

THOMAS GILL

"The Vale of York is the most beautiful and romantic vale in the world, the Vale of Normandy excepted."—CHEVALIER BUNSEN.

LONDON:
SIMPKIN, MARSHALL & Co., STATIONERS' HALL COURT;
R. SUNTER, STONEGATE, YORK; AND THOMAS GILL,
EASINGWOLD.

Dick Turpin and his Daring Robberies and Burglaries

Easingwold has a long history of publishing and printing. The two old pictures show *The Life of Richard Turpin*, a chapbook co-published by Thomas Gill – author, publisher and printer – in 1830. Turpin, of course, was hanged in 1739 on the York Knavesmire for horse-stealing; the cover shows him accidentally shooting Tom King, his accomplice. *Vallis Eboracensis Comprising the History & Antiquities of Easingwold and the Forest of Galtres* was another Gill publication of two volumes published in Chapel Street in 1852. Gill's successors today are G. H. Smith & Son, based in Market Place, the publisher and printer who produced the facsimile editions of *Vallis Eboracensis* in 1974. The modern photograph shows Smith's offices in the former town hall.

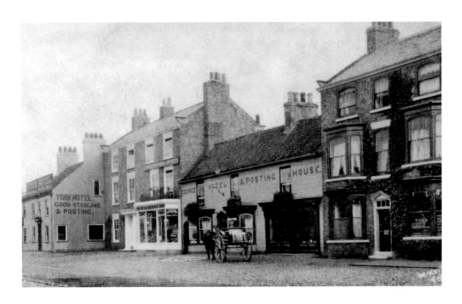

The George Hotel

An eighteenth-century posting house where horses could be watered, rested or exchanged here for the onward journey to Newcastle and Edinburgh. In 1776 the cost for a post horse was 3*d* a mile, for a post chaise 9*d* and for a four-horse chaise 1*s* 3*d*. This was the *Newcastle Fly*, which travelled between the George in Coney Street, York, and the Cock in Newcastle every Monday, Wednesday and Friday at 3.00 p.m. and took the best part of a day and cost one guinea. In 1784 the *Newcastle and Edinburgh Diligence* took over the route. The Butter Cross here is a reconstruction of an original cross and there was a bear-baiting ring where the north end of the Town Hall is now. The shop in between the York and the George is Bannisters, family grocer's, hay and forage suppliers, agricultural seeds and cakes and wines and spirits. Simpson's Boot and Shoe Depot is next to the George with a branch of the York Union Bank Ltd next to that.

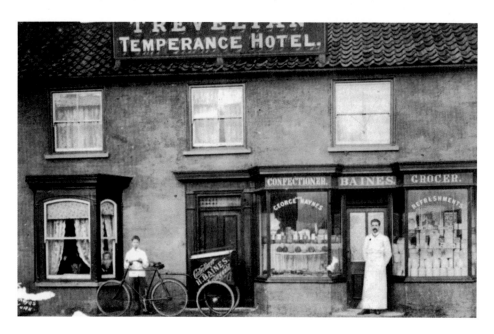

The Trevelyan Temperance Hotel

The other side of the alcohol coin is represented by the Trevelyan Temperance Hotel in Long Street – probably named after Sir Walter Calverley Trevelyan (1797–1879), president of the UK Temperance Alliance (there are other such named hotels in Leeds and Halifax). The shopkeeper is Hubert Baines who bought the premises from George Haynes, whose name is still featured in the window. The delivery boy is a Barnardo's orphan. Note the inquisitive little girl peering through the left-hand window. Elegant houses on the green make up the modern picture.

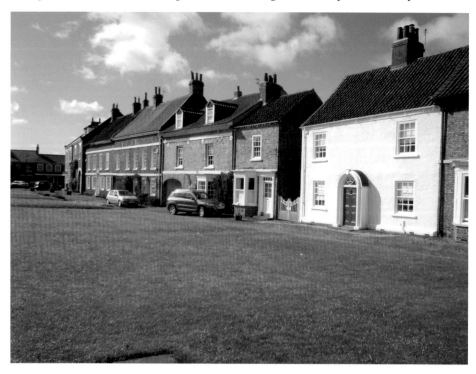

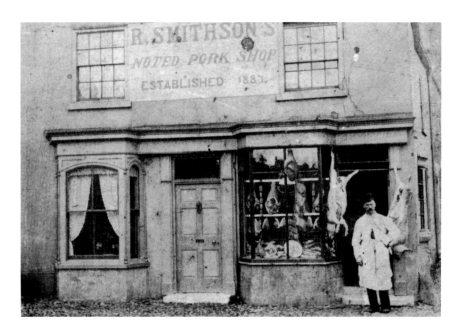

Smithson's, Pork Butcher's

Butchery has taken place on this site since 1887, when R. Smithson ran a pork butcher's here. Today it is Thornton's (see page 60). The recent picture shows a good example of contemporary retailing in Easingwold's Chapel Street in the form of Green Ginger with its highly imaginative window display. The register of burials for any town usually makes interesting reading, and Easingwold's for 1777–80 is no exception: sixteen children died of smallpox, twenty-one adults of consumption, four (children) of whooping cough, four from dropsy (heart failure); one in childbirth; two from mortification of the bowels and one each from apoplexy (stroke), palsy (paralysis), marasmus (malnutrition), gravel (kidney stones), bladder inflamation and asthma.

The Easingwold Poor Law Institution

This shows the road house for casual vagrants, annexed to the workhouse (see page 52). The Claypenny workhouse here replaced an earlier institution, some of the rules of which are interesting: no ale or spirits except by order of the surgeon; men and women to sit separately; no smoking at meals; children to be separated from parents; no smoking after 7.00 p.m. Menus included boiled beasts' heads with potatoes for dinner on Fridays and beasts' hearts roasted with potatoes on Saturday.

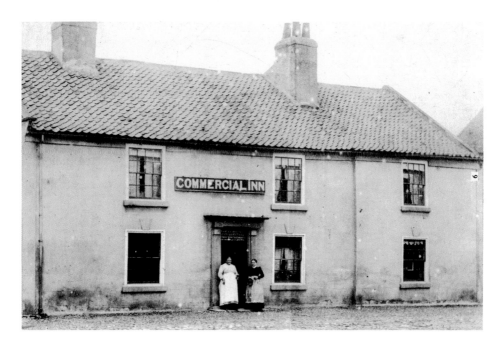

The Commercial Inn

The Market Place had been assigned to George Hall on behalf of the town in 1646 on the condition that he built a toll booth and looked after the surrounding pavements. High and Low Meat Shambles were in the middle of the market place and were replaced by the 1864 town hall. The Commercial Inn is situated at the opposite end to the town hall on the site of the Old Unicorn. Tom Cowling died from excessive drinking at the Royal Oak in Long Street in 1825 and William White suffered the same fate when he inadvertently drank a pint of rum instead of ale in the Unicorn, also in Long Street. In 1838, a broken-hearted Mary Scaife from Ripon hanged herself in the kitchen of the New Inn, again in Long Street; a verdict of Temporary Insanity was returned.

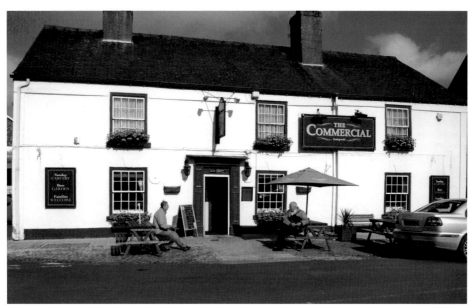

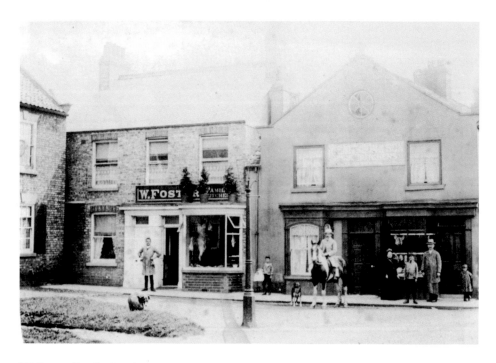

W. Foster Family Butcher

W. Foster was situated next door to Smithson's in Little Lane. Easingwold, like any market town, had its fair share of butcher's, baker's, blacksmith's and wheelwright's, but more specialist occupations were starting to emerge in the eighteenth century: a writing master, clockmaker, cabinet maker and a dancing master.

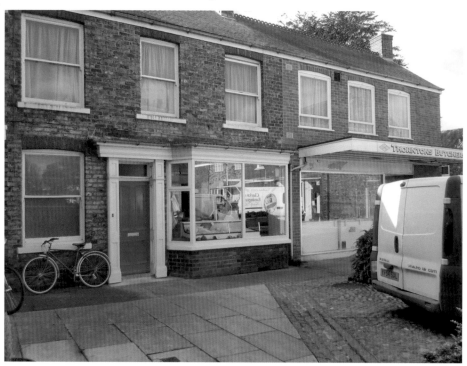

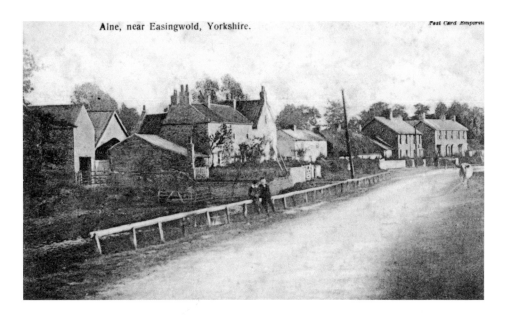

Alne: St Mary the Virgin and the Bestiary

The name of the village comes from the Latin *alnus*, alder tree, after the alders that grew here. The church is St Mary the Virgin (not to be confused with St Mary Magdalen at Great Alne, Warwickshire) notable for its Norman doorway with unique carved animals (taken from the medieval, largely Bible-based *Bestiary*) and the fourteenth-century effigy in the Lady chapel, which is described movingly as follows: 'The broken figures at her head are angels waiting to catch her soul in a veil and take it to heaven'. The modern picture shows the large Norman font incorporating a green man.

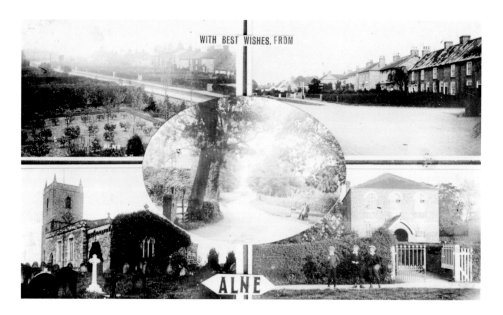

The Caladrius

On 18 December 1944, a Halifax bomber from the Royal Canadian Airforce crashed, shortly after take-off from Tholthorpe, with its full load of bombs, on the village. It destroyed houses and one of the church windows; the window was replaced in 1958 (visible through the doorway) and there is a dedication to the eight crew members who died. Among the *Bestiary* carvings around the door is one of the few surviving depictions of the Caladrius, which medieval people believed could predict whether the very ill would live or die as indicated by the bird either looking the patient in the face or averting her gaze.

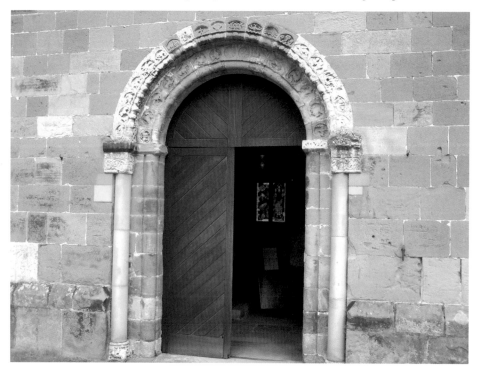

Raskell Town and Rascal People, Drunken Parson and Wooden Church Steeple
Raskelf comes from the old Scandinavian words *ra* (roe deer) and *skjalf* (shelf).
Domesday has it as Raschel – as it is still often pronounced today. The village
has two particularly fascinating features, the first of which is the twelfth-century
St Mary's fifteenth-century timber tower – one of only two in England, the
other being St Andrew's at Greenstead-juxta-Ongar. Captain Augustus Frederick
Cavendish Webb of the 17th Lancers is commemorated in the north chapel,
after dying of wounds sustained at the Charge of the Light Brigade at Balaclava
in 1854. The image here was first published in Thomas Gill's *Vallis Eboracensis
Volume II* 1852.

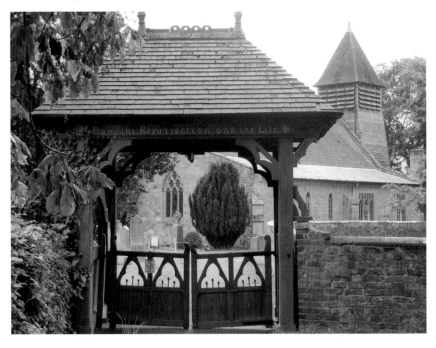

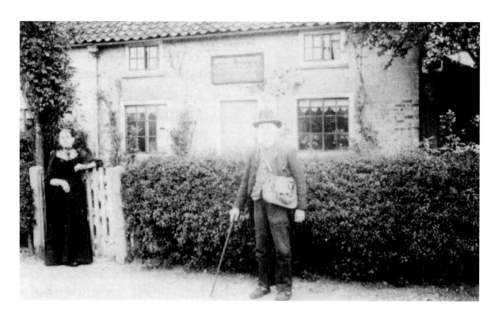

The Old Post Office and the Old Pinfold

The second special feature is the Old Pinfold, or pound, described by B.M. Wilmot-Dobbie in *Pounds or Pinfolds, and Lockups* (1979) as follows: 'At the cross roads in the centre of the village stands the Old Pinfold. It is octagonal in shape, 10" brick walls about 11 feet high and castellated. A pointed doorway and arched barred windows, 18th century. Unique design quite Gothic.' Pinfolds were built to hold animals that had strayed from their owner's land or were found grazing on common land without common rights. They were released after a fine or mulct had been paid to the pinder. Breaking into a pinfold to release animals was punishable by a fine or imprisonment.

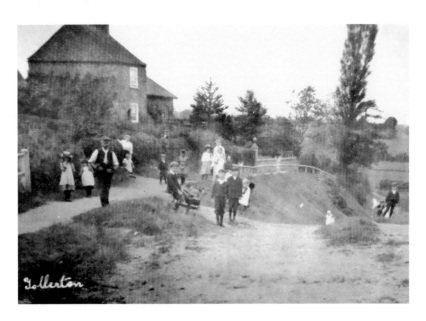

Tollerton and the *Banditti*

The name probably comes from the village's position at one of the toll entrances to the Forest of Galtres, where, according to Verstegan, travellers were given an armed guide to escort them as they travelled on to Bootham Bar, York. Gill, in his *Vallis Eboracensis*, adds, 'it [the forest] was the lurking place of large hordes of banditti, who dwelt in caves and lived upon rapine and plunder'. In the seventeenth century, the village was famous for horse racing on land close to the Great North Road. Drunken Barnaby, a celebrated road writer, tells us:

'Thence to Towlerton, where those stagers,
Or horses courses run for wagers;
Near to the highway the course is,
Where they ride and run their horses;
But still on our journey went we,
First or last did like content me.'

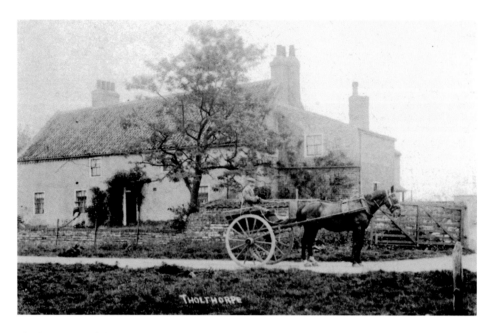

Tholthorpe and the Royal Canadian Airforce

Tholthorpe is perhaps best known for its Second World War RAF station and, in particular, for the Canadian squadrons that flew Halifaxes and Lancasters from here from June 1943. Altogether 119 Halifax bombers were lost from Tholthorpe. The new picture shows the monument made from Canadian granite. There is also an avenue of oaks and maples, which led from the village green to the airfield in honour of the fallen airmen.

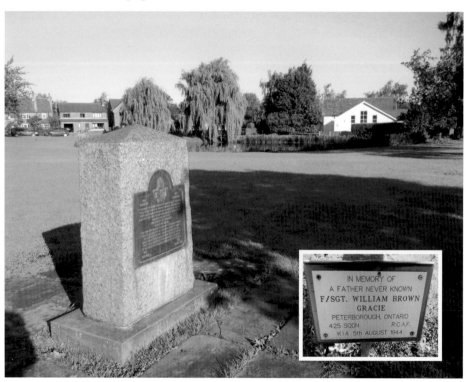

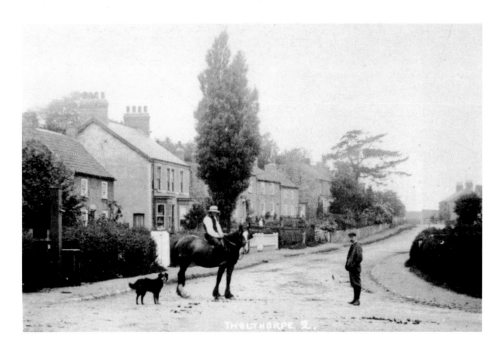

Tholthorpe

Tholthorpe has Viking origins and is recorded in Domesday as *Turolfestorp* and *Turoluestorp*. The school, now used as a village hall, was built in the mid-1830s and the Wesleyan chapel in 1844. The shop and post office closed in 1993. One of the two pubs – the Plough Inn – has also gone, although the New Inn continues to serve today. Ducks replace horses in the pictures.

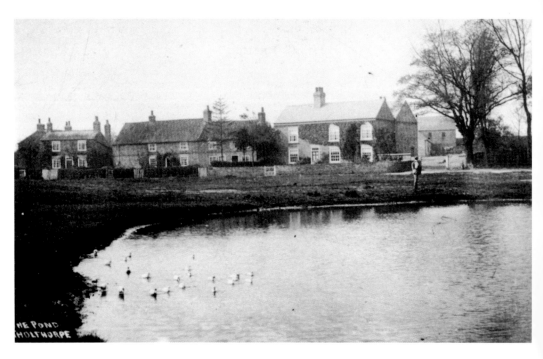

Tholthorpe's Red Pond
Famous for the algae, *Eugleana Sanguena,* which sometimes grows here and turns the pond red...
but not on the day this photograph was taken.

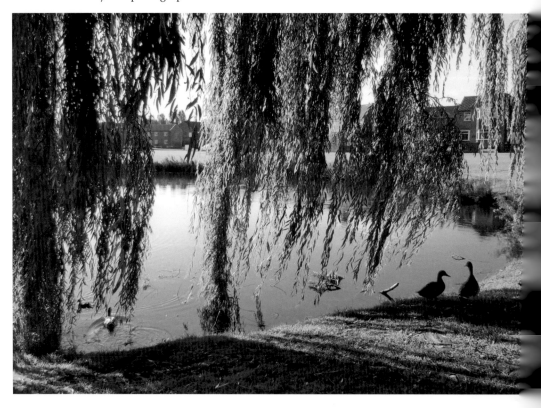

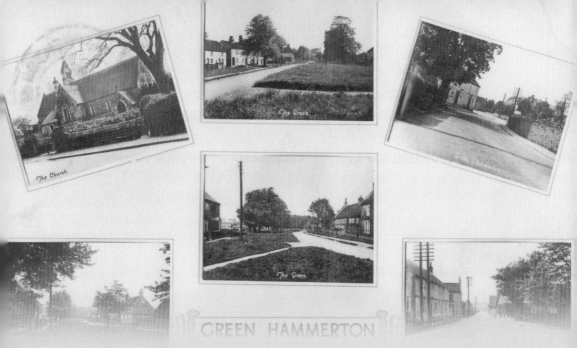

The Church · The Green · The Green · GREEN HAMMERTON

CHAPTER 5

West of York

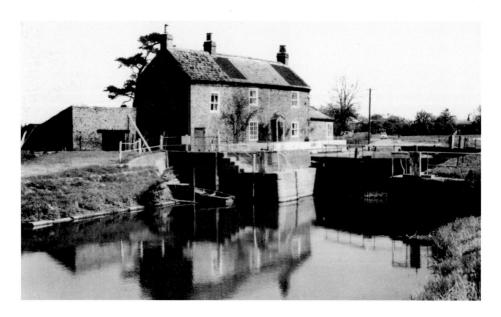

Linton-on-Ouse

The Manor of Linton was originally owned by the Catholic Appleby family and then bequeathed to University College, Oxford by a Dr John Radcliffe, Queen Anne's physician, in 1714. He stipulated that the rents raised should pay for scholarships for two medical students. By 1977 the farms, houses and other buildings had reverted to private ownership. The village is well known for its RAF station and is today the home of No. 1 Flying Training School. During the Second World War it was a bomber base and Squadrons 408 and 426 of the Royal Canadian Air Force, among others, were stationed here. In 1940, after a raid on Cologne, Flying Officer Leonard Cheshire succeeded in getting his badly damaged Whitley bomber back to Linton, for which he was awarded the first of his three DSOs. The old photographs of Green Hammerton on page 69 are from around 1933. The newer photograph is of the attractive green at neighbouring Newton-on-Ouse.

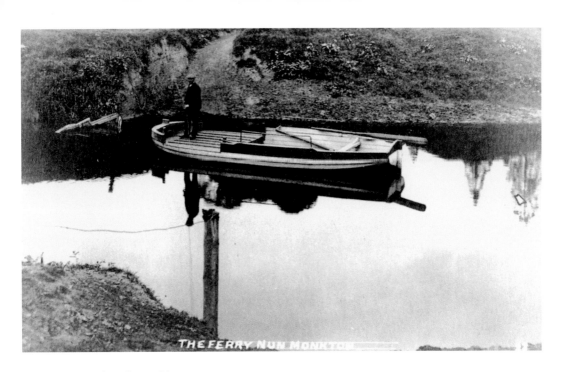

Nun Monkton's Working Green

On the confluence of the Ouse and Nidd, Nun Monkton was an estate village until 1934 when the estate houses were sold off. The village green is to this day grazed by cattle and is one of the last working greens in Yorkshire. The Alice Hawthorn public house, originally the 1787 Blue Bell Inn, is named after the 1840s winner of the Doncaster Cup and Queen's Vase.

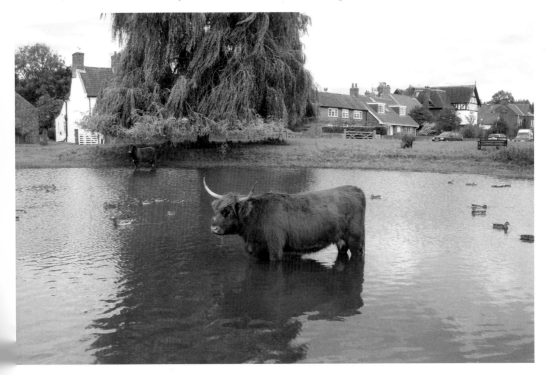

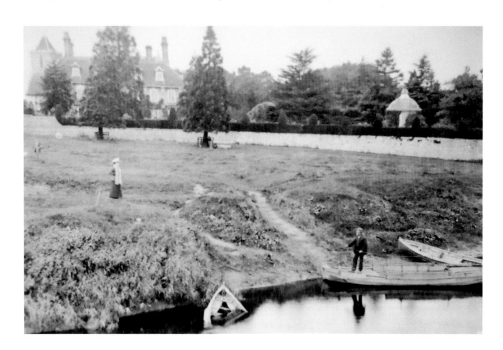

Digging Up St Peter

The Monkton part of the name may well be due to a small monastery from the pre-Viking period, complemented in 1172 by a Benedictine nunnery set up by Ivetta of the Arches, the Anglo-Norman owner of the village. The nunnery lasted until the Dissolution, despite pleas from Anne Boleyn that it be spared. Until the mid-nineteenth century (when it was stopped because the then vicar considered it to be pagan) Nun Monkton traditionally performed the annual ceremony of digging up, parading, and reburying a statue of St Peter, the village's patron saint. The ferry was closed in the mid-twentieth century. However, little has changed as the new photograph, a picture of serenity, clearly shows.

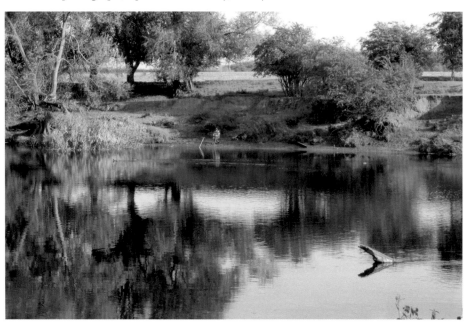

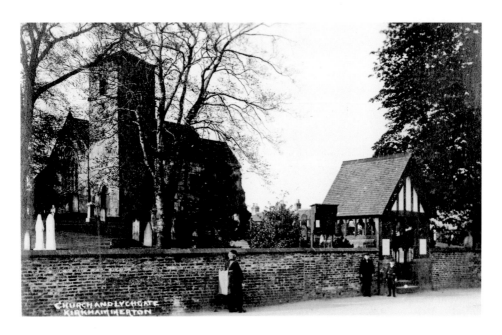

Kirk Hammerton's Saxon St John the Baptist

Hammerton features in Domesday as, 'Hanbretone' or 'Ambretone' under the lands of Osbern de Arches, which included a mill and a fishery. The church is Saxon from around AD 950 and, unusually for a Saxon church, is built in stone. For the first 600 years of its life it was dedicated to St Quentin. It is thought that casualties from the Battle of Marston Moor in 1644 are buried in mass graves in the churchyard, as a number of skeletons were dug up in 1926 and are thought to be from the battle.

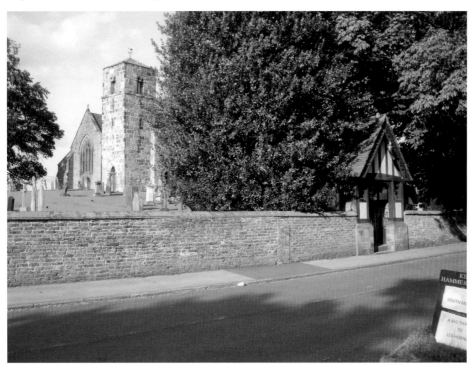

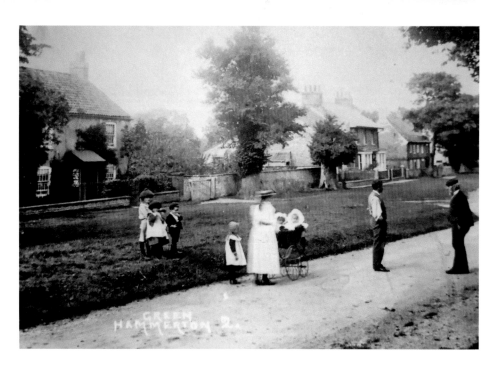

Green Hammerton

The 1870 Catholic chapel in Nun Monkton closed in 1949 not long after the ferry ceased operating. In 1961 the parish bought the former Congregational church in Green Hammerton; it had originally been built as a Methodist Chapel in the late 1790s. The chapel is very simple; there are no statues apart from the one of St Joseph taken from the Nun Monkton church.

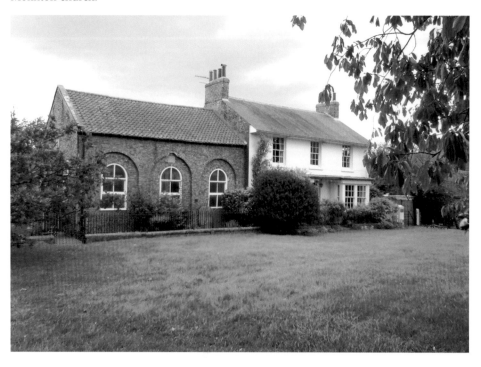

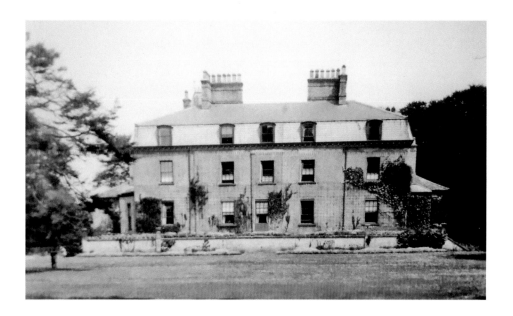

Green Hammerton Hall – Alleluia Tommy, Dick Turpin and Wishy Watson

Green Hammerton Hall has now been demolished. The Hammerton Hotel on the A59 was built as a road house by Bentley Breweries of Leeds in the early 1930s. It was bought by the Bensons in 1992 and converted into the furniture store, which remains today. In 1861 there were four pubs in the village: the Sun, the Railway Tavern, the Rose and Crown Inn and the Victoria. Up until the 1970s Bensons also had a shop, called the Adams House, in Petergate, York. Green Hammerton is famous for three characters: Alleluia Tommy, real name Thomas Segmore, a prominent Methodist, who lived here; Dick Turpin who lodged here on his way to York; and Wishy Watson who habitually slept in a tree at the north end of the green.

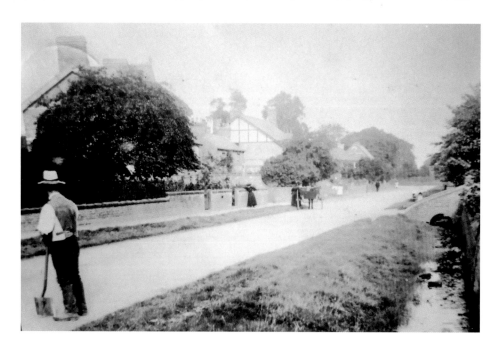

York Harness Raceway

Horses feature in both these scenes in and near to Kirk Hammerton. The newer picture shows *Limited Edition*, one of the runners in the first race of the 10 September 2011 York Harness Raceway, owned, trained and driven by Kelly Peacock. The owners of Kirk Hammerton Hall, Mr and Mrs Stanyforth, built the village hall in 1897 to celebrate Queen Victoria's Diamond Jubilee.

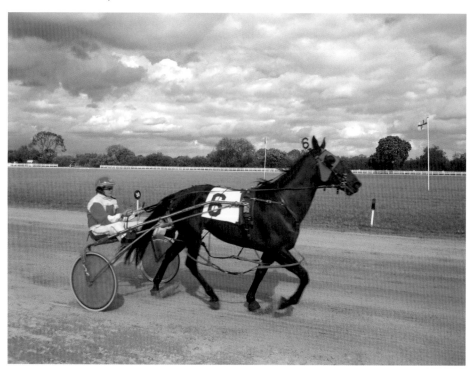

BANK AND PLAYING FIELDS.

THE WEIR

WETHERBY CHURCH.

WETHERBY

CHAPTER 6

In & Around Wetherby

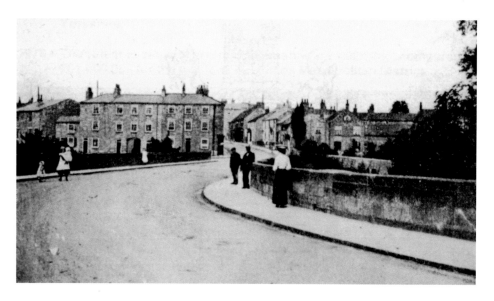

Wetherby Bridge

A scheduled ancient monument and a Grade II listed structure, Wetherby Bridge carried the Great North Road over the River Wharfe here until it was bypassed by the A1 in 1962. The Wharfedale Brewery can be seen in the centre. During the First World War it was requisitioned to billet troops, and then taken over by Oxleys mineral water company. In 1943 it used to make Coca Cola for the many American troops in the area. The West Yorkshire Bus Company later occupied the offices until it was all demolished to make way for a new bus depot in 1959, itself replaced in 1994.

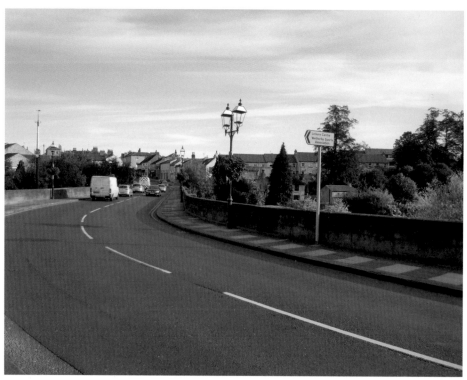

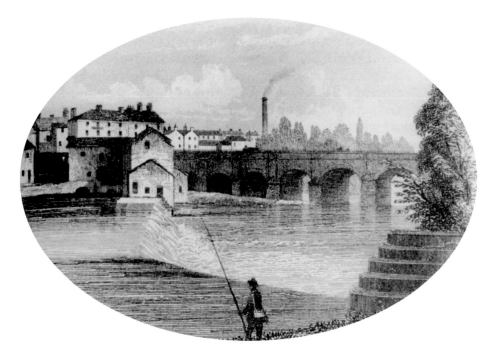

Wetherby Bridge, Weir and Mills

The water wheel is from the Old Mill at the end of the weir, repositioned by Persimmon Homes in 1993 when they converted the Old Mill to luxury apartments. This 1857 engraving was published in February 1857 by Henry Crossley who founded the *Wetherby News* and was landlord of the Angel Hotel. The blue plaque for the bridge reads: 'In 1233 Walter de Gray, Archbishop of York, forgave the sins of those who contributed to the building of this bridge. The original was only 3.6 metres wide and humpbacked. Frequently repaired, it was widened and raised in 1826. The present bridge is the result'. The chimney is at the gasworks, built in 1845.

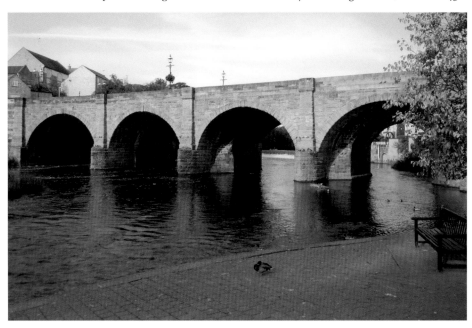

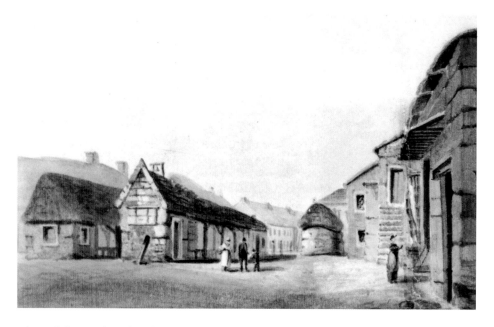

View of the Market Place in its Present State, 1811

An early watercolour showing the Market Place around the time the 6th Duke of Devonshire was improving parts of the town (in preparation for its sale in 1824 to pay for Chatsworth House). It shows, from left to right, market sheds, the Three Masons public house, more sheds, the town hall and courthouse, and the blacksmith's forge on the right. The market goes back to Henry III who granted a charter to the Knights Templar in 1240, giving Wetherby market status.

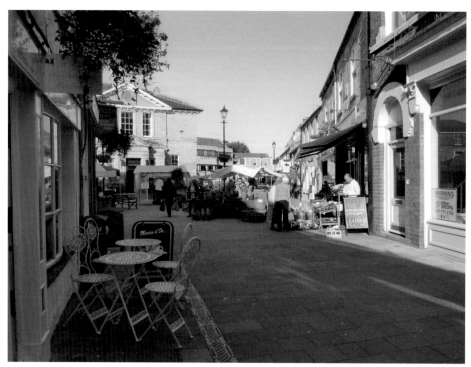

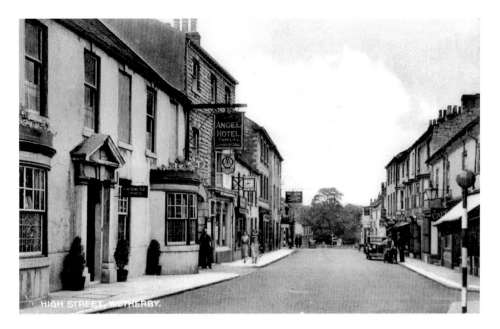

High Street

As an important staging post on the London to Edinburgh route (it is 198 miles equidistant from London to Edinburgh) Wetherby had its fair share of inns, coaching and post houses. The Angel Inn was one of nine listed in the 1776 census in the High Street with a further three in Market Place and three others in the town. The Angel alone in Wetherby had a smithy and shoeing shop. Between the Angel and the Swan and Talbot there were twenty-five servants employed. The Angel Hotel is now the Sant Angelo Italian restaurant.

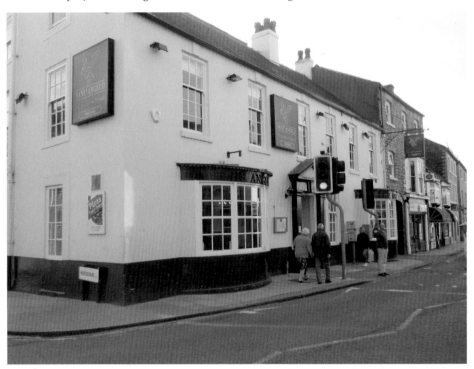

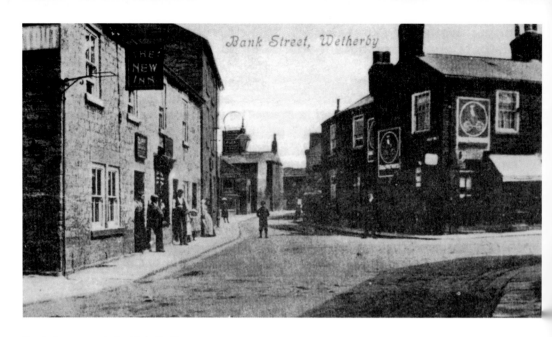

Bank Street and the Fish Pedicure

The New Inn is on the left and beyond that the Fox Inn in Bank (formerly Back) Street. The Fox was unusual because it did not form part of the Duke of Devonshire's estate and so was not included in the sale. The sign on the near right above Alfie's advertises fish pedicures and shows just how far things have moved on here.

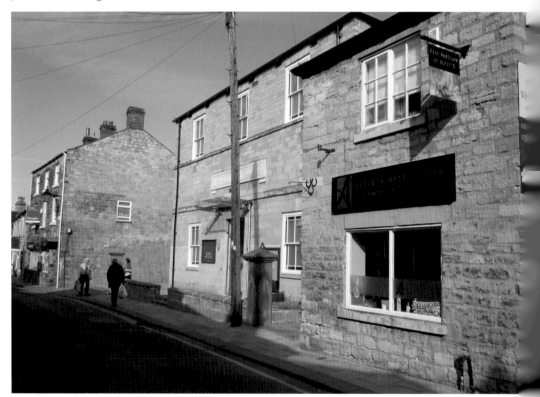

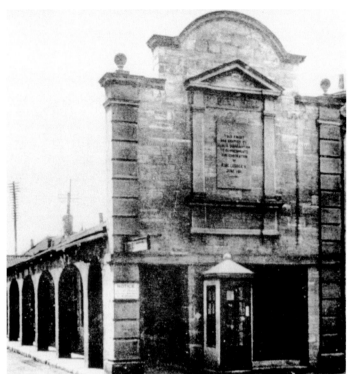

The Shambles
Originally built as a parade of ten butcher's shops, this grand building was converted into a market hall in 1888. It was built in 1811 by the Duke of Devonshire with the stipulation that it only opened on market day. The façade was added in the early twentieth century.

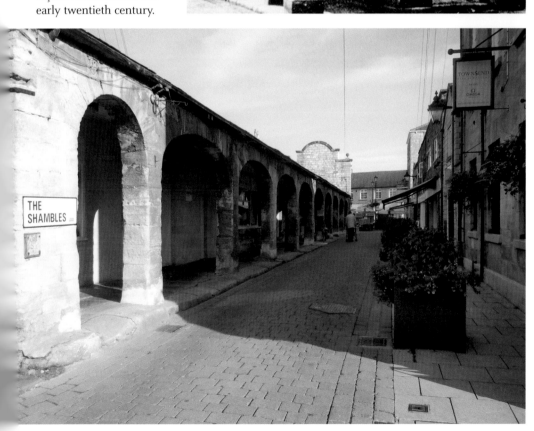

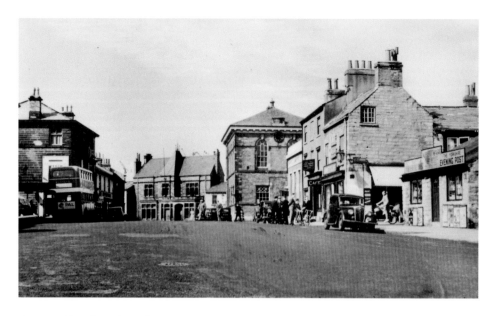

Town Hall and Market Place, 1945

The town hall on the right was built on the site of a chapel. The tall, narrow windows of the Assembly Rooms can clearly be seen while the courtroom and cells are to the right, out of shot. It replaced the original courthouse and Wetherby prison and has had many uses down the years including the Wetherby Statute Fairs, which were held here every November for the hiring of servants.

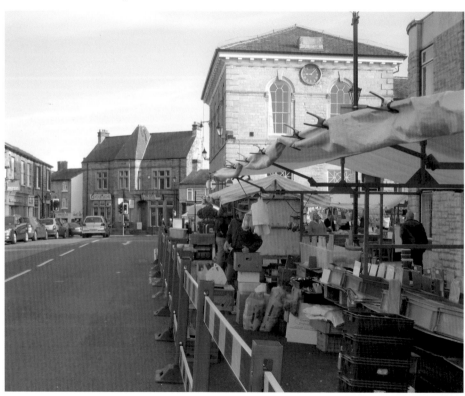

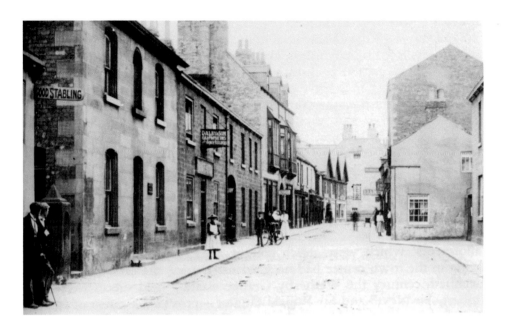

North Street Looking South

The building on the left is the York County Savings Bank with Dalbey's garage next to that and their house next door. The Magnet Ales pub is the Angel and 'good stabling' can be obtained at the Swan & Talbot coaching house, a Cameron's house in those days. 1786 saw the arrival of the first mail coach in Wetherby. The new picture shows the Garden of Rest on the right (see also pages 86 and 87).

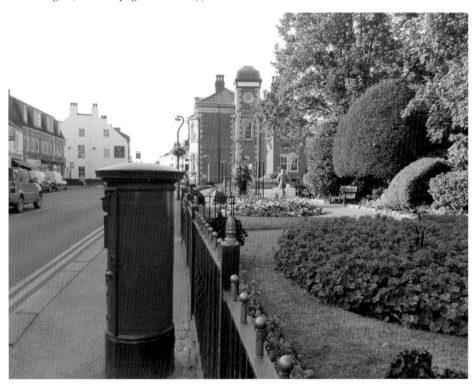

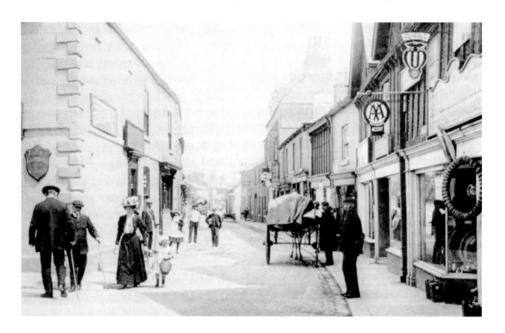

North Street Looking North

The building on the near left is the Bowling Green Inn (named after the bowling green behind), which was demolished in 1929 as part of a road-widening scheme to allow the Great North Road to flow more easily through the town – in theory at least. In the modern picture we can see the 1827 Huguenot Arch to the left. The blue plaque here tells us that this was an archway between two buildings in West End, now Westgate, built by French protestant refugees. The French inscription translates as, 'Love thy neighbour as yourself, said the Evangelist'.

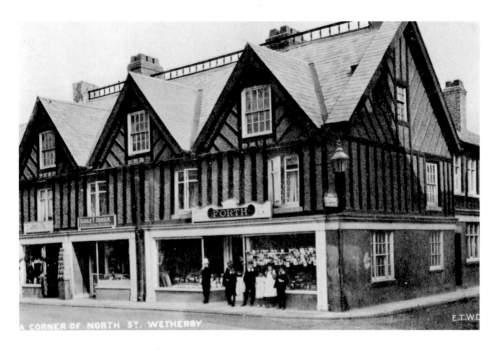

North Street Corner and the Huguenot Arch

Mock-Elizabethan shops on the corner of North Street and Horsefair. Forth's premises were later taken over by Teasdale & Metcalfe Ltd, industrial buildings and Dutch Barn manufacturers. Next door was Harold Denham's butcher, and next door to him was James Fox, saddler and harness maker. Before becoming Forth's the premises was Wm Ward & Sons' garage, sole district agents for Triumph, Rover, Bradbury, New Hudson and Torpedo.

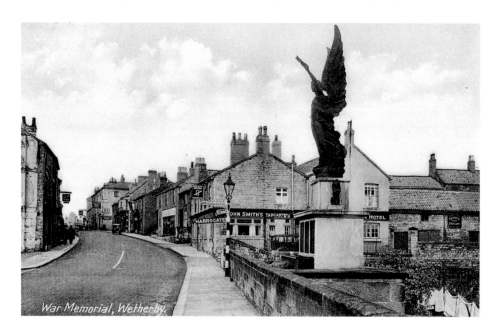

War Memorial, Wetherby.

The War Memorial

The memorial on Wetherby Bridge was dedicated on 22 April 1922. It is a bronze angel holding a wreath of laurel and pointing a sword towards the ground. A gun and shell case, situated nearby, has since been removed. Many of the listed served in the 5th or 9th West Yorkshire Regiments who fell in Flanders. The bridges have a chequered history; during Henry III's reign in the mid-thirteenth century it was a narrow, eleven-foot-wide humped construction. This was improved in 1662 and partially paved. The 1767 floods caused some damage, which was repaired and resulted in the widening of the bridge in 1773. The present six-arch bridge was built in 1824 using the old arches as its foundations.

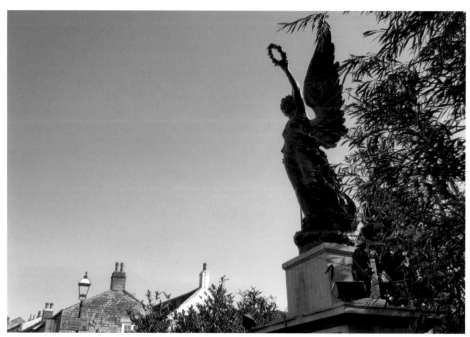

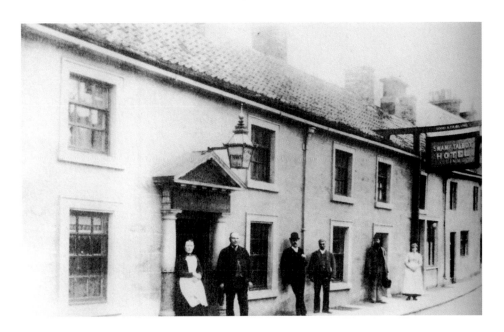

The Swan & Talbot

This building was sold for £1,510 in the great Wetherby sale. The Swan & Talbot coaching inn has the dubious distinction of receiving a direct hit from a German incendiary bomb during the Second World War. It went through the roof and two floors, only to burn itself out on the cellar floor. The inn was originally called the Dog & Swan and was permitted until 1611 to bear the coat of arms of the Swann family from Askham Manor in Askham Richard. The dog in question was a talbot hound – a hunting dog, similar to the beagle, and now extinct. The name was then changed to the Swan & Talbot.

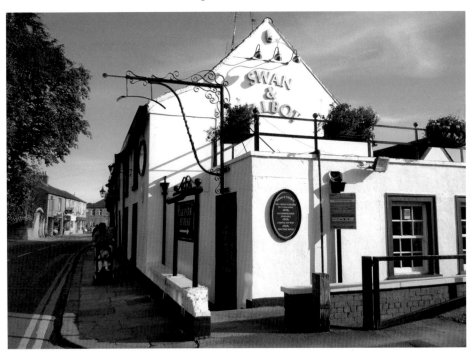

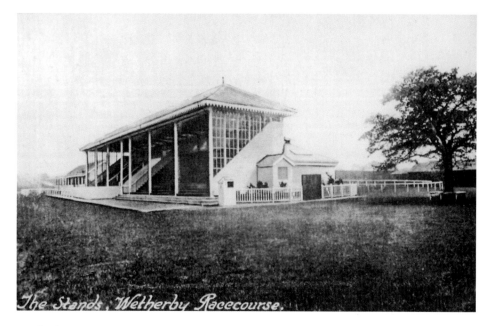

The Stands, Wetherby Racecourse.

Wetherby Racecourse

Built in 1891, the first race started on Easter Monday that year. Previously there had been racing at Wetherby in various locations since 1683. The old picture shows the stands built in 1922, which lasted until 1967 when the new stands were built, pictured here. The Millenium Stand was built in 2000 as a 'state of the art viewing facility'. The Wetherby Steeplechase Committee Ltd was founded in 1920 by Captain F. Osbaldeston Montagu OBE, MC, of Ingmanthorpe Hall – the grounds of which the racecourse is built on.

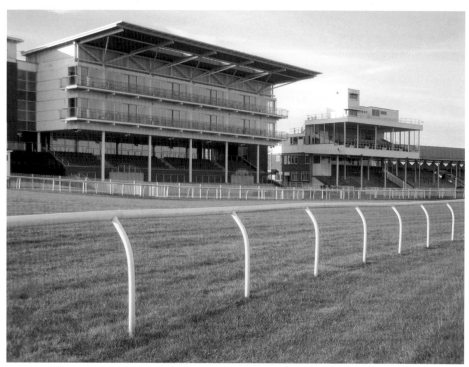

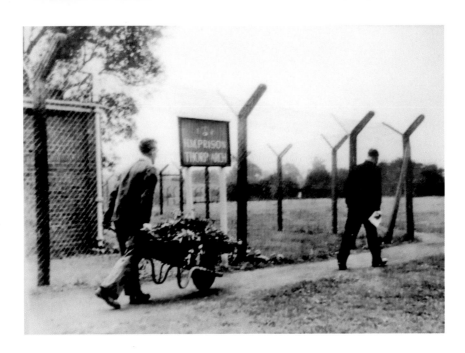

HMP Thorp Arch

The prison at Thorp Arch is pictured in the old photograph. Hostels for the munitions workers at Thorp Arch Ordnance Factory were built at Hallfield Road (now Wetherby High School) and on York Road during the Second World War, each accommodating around 1,000 workers. York Road was requisitioned in 1943 by the Admiralty to become HMS *Cabot*, later HMS *Demetrius* and later still HMS *Ceres* until 1958. *Cabot* had the distinction of being reported sunk by Lord Haw-Haw. It was the only land ship north of Chatham. The contemporary photograph is of HMYOI *Wetherby*, a Secure Learning College in York Road.

A Floral High Street

These two photographs show that Wetherby's reputation as an attractive floral town is well deserved over the years.

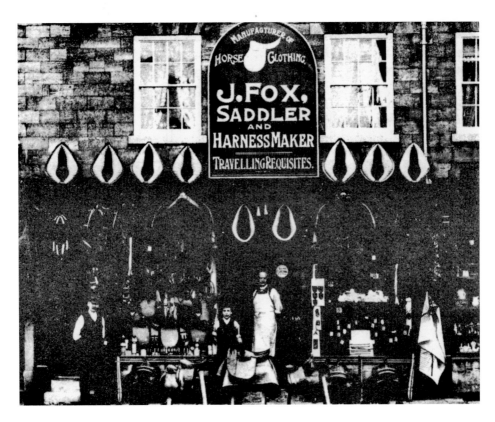

J. Fox, Saddler

Fox's has been in Wetherby for over a century with premises once in Market Place (pictured here), North Street, and, as in the new photograph, in Northgates. They are still a working saddler's with a workshop that makes and repairs saddlery and leather goods. They also provide an saddle-fitting service by qualified fitters.

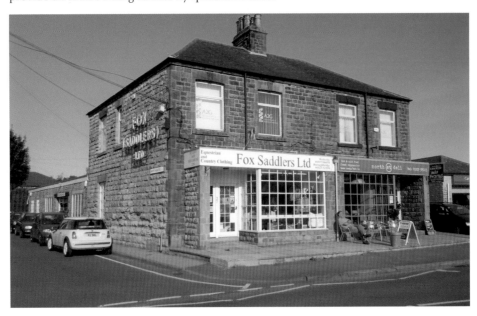

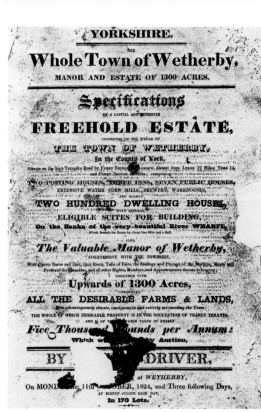

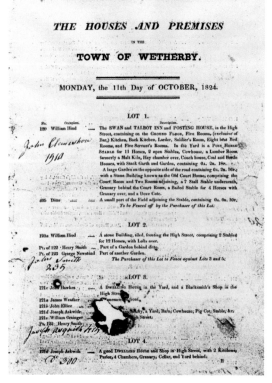

The Great Wetherby Sale

Pages from the catalogue of the Duke of Devonshire's sale of the town of Wetherby in 1824 to finance his building of Chatsworth. For the sale, Wetherby Estate was portioned into 170 lots. On the eve of the sale, the Leeds Intelligence reported, 'The Inhabitants of Wetherby, judging from the dilapidated state of their houses, a stranger would conclude, had been excluded from the rest of the world for the last fifty years, or that a law had been past [sic] to prohibit both the carpenter and bricklayer coming amongst them.' The highest price paid was £8,100 for the two corn mills; twelve iunns were sold, three of which raised more than £1,500.

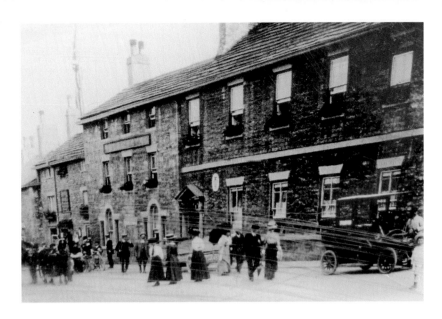

Boston Spa Crown and Royal

Pubs at 128 and 182 High Street Boston Spa. During the Second World War, Thorp Arch was the home of a Royal Ordnance Factory ammunition-filling factory. It produced light, medium and heavy gun ammunition, land mines and trench mortar ammunition for the army, medium and large bombs for the RAF, and 20mm and other small arms ammunition for all three services. Some of these were produced in millions and hundreds of millions of units. It finally closed in 1958 after the Korean War. Part of the site now houses the Northern Reading Room, Northern Listening Service and Document Supply Collection of the British Library. Over 100km of shelving is devoted to interlibrary loans. The rest is occupied by Thorp Arch Trading Estate and two prisons, now combined as Wealstun Prison.

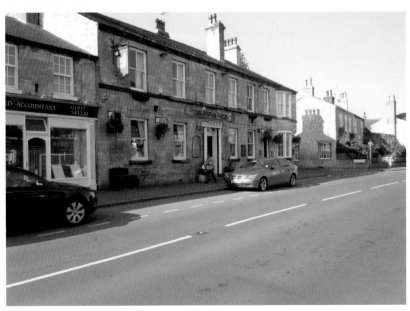

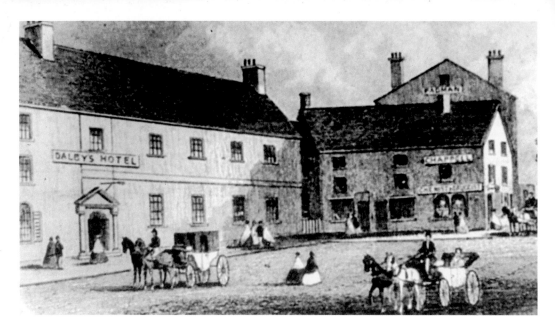

Daley's Hotel

This hotel was established to cater for visitors who came to take the waters. In 1744, John Shires discovered magnesian, limestone and sulphur springs and so made Boston a spa town known then as Thorp Spaw. It declined around the same time as Harrogate's fame was increasing.

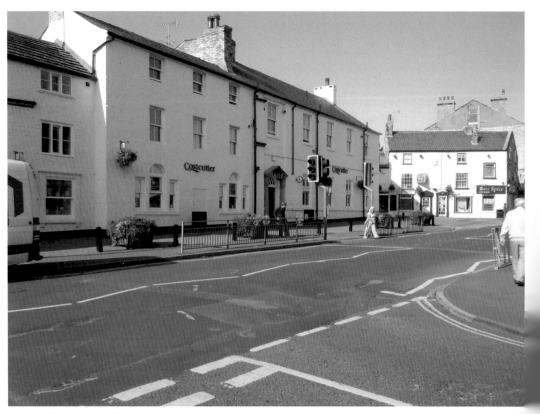